BLACK AMERICA SERIES

NASHVILLE
TENNESSEE

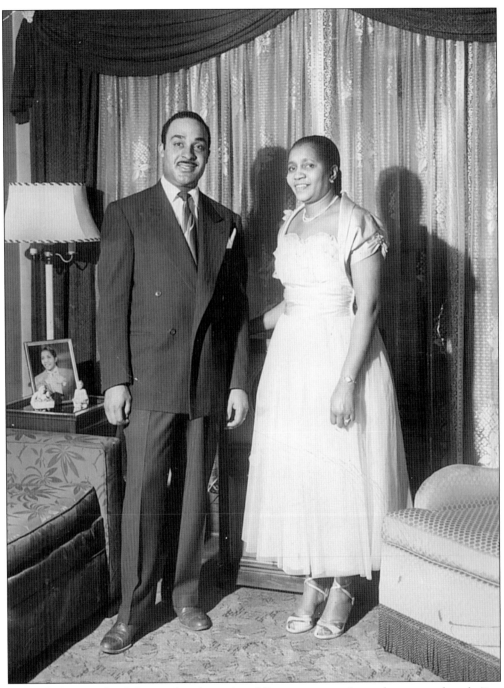

Nashville's versatile club Paradise hosted public concerts, private dances, and a skating rink. Beatrice and Bremer Harris pose in the 1940s on their way to the Paradise for a social club dance.

BLACK AMERICA SERIES

NASHVILLE
TENNESSEE

Tommie Morton-Young, Ph.D.

ARCADIA

Published by Arcadia Publishing
Charleston SC, Chicago IL, Portsmouth NH, San Francisco CA

Printed in the United States of America

Library of Congress Catalog Card Number: 00-106475

For all general information contact Arcadia Publishing at:
Telephone 843-853-2070
Fax 843-853-0044
E-Mail sales@arcadiapublishing.com

For customer service and orders:
Toll-Free 1-888-313-2665

Visit us on the internet at http://www.arcadiapublishing.com

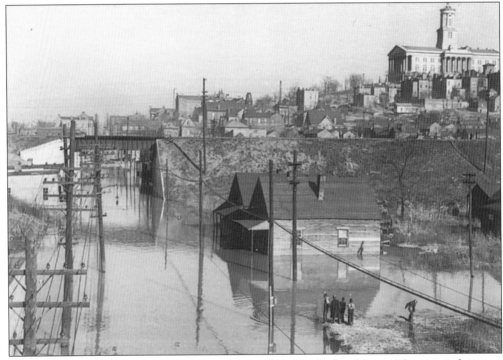

Early on African Americans tended to settle near the Cumberland River. The river's frequent flooding kept some areas in a constant state of mudholes, moisture, and depression. Flooding in 1939 surrounded Capitol Hill and struck hard at the black homes and businesses on Cedar Street and Jo Johnston, extending over to Eighth Avenue. Work in maintaining levees was provided by the black men in the area. Frequent flooding also kept residents in the low land beyond Tennessee State in flux. (Photo courtesy of the U.S. Corps of Engineers.)

CONTENTS

Acknowledgments

The author of this book is grateful to the agencies, individuals, institutions, and families for their assistance and cooperation in the compilation of this work.

Belle Meade Plantation
Bethlehem Centers
Capers Memorial C.M.E. Church
Cheekwood Nashville Home of Arts and Gardens
Fisk University Library, Special Collections
Girl Scouts of America
Grace M. Eaton Day Care Center
Greenwood Cemetery
Haynes School Alumni Association
Meharry Medical College Archives
Metropolitan/Nashville Archives
Metropolitan Historical Commission
Metropolitan/Nashville Public Library, Nashville Room
National Baptist Publishing Board
Pearl High School Alumni Association
Tennessee State University Athletic Department
Tennessee State University Library, Special Collections
Tennessee State University Public Relations Office
United States Corps of Engineers

INTRODUCTION

From frontier town to metropolis, the African-American presence in Nashville has been felt and its contributions visibly noted. Arriving with James Robertson from North Carolina, a black man was a member of the party that lay down stakes in the rocky terrain that has been called "rock city."

Early settlers both black and white fought the local Native Americans. Blacks were sometimes captured and killed. Other times they were overcome and enslaved. Often they married into the tribes. Nashville's early settlers included Europeans and Yankees. Many of these settlers are said to not have been committed slaveholders. An interesting mix of population evolved among the black community, consisting of free, quasi-free, and enslaved African Americans.

Many blacks, bond and free, came from Virginia and North Carolina and brought with them certain perceptions and ideas. Early on, black Nashvillians gave evidence of their principal views of their lives. They took great pride in family, pursued education often under tedious circumstances, appreciated self-help and the meaning of social service, participated in recreational and cultural activities, had an eye for profits and entrepreneurship, and appreciated politics and the vehicle of protest.

During the Civil War many blacks drifted into the city and contraband communities formed within and around the city. Upon Emancipation, many blacks poured in from neighboring counties such as Williamson, Maury, and Marshall. Less explored is the relationship of the ethnic origins of early black settlers and the black Nashvillians' outlook and expectations. Moses McKissack I, of the famous architectural family and firm, was of the Ashanti ethnic group of Africa and many Middle Tennessee blacks can claim that heritage. The Ashanti are known as proud and resourceful people.

As early as the 1700s Robert Renfro, a free black man, owned a tavern and Andrew Jackson often patronized the place. Free blacks ran hacks, barber shops, and stables. Nashville's black politicians were once praised as being the most astute politicians among African Americans.

During Reconstruction, African Americans were active in politics and were elected to various public posts. Others were appointed from time to time. With the coming of Jim Crow Laws and the Poll Tax, political and public office life was quelled. Black Nashvillians did not idly stand by as their rights were denied. Black leaders organized a public transportation company to circumvent segregated street cars. African Americans

participated in boycotts, established alternate businesses preferring to "separate rather than segregate," and led protest marches to express black dissatisfaction with inequality and injustice.

Over the years blacks were influenced by Booker T. Washington, who was a good friend of political leader J.C. Napier, and the philosophy of business entrepreneurship was a guiding force. The black community was also influenced by W.E.B. DuBois, who called for the "Talented Tenth"—black professionals, philosophers, and thinkers.

Blacks operated and continue to offer most of the businesses and services needed for a community. The banks and publishing houses, the hospitals and clinics, and the multiple institutions of higher learning and their involvement in the political life of the city mark Nashville as a progressive city for blacks. African Americans have made their mark in the growth and development of the "Rock City."

One

FAMILY AND COMMUNITY

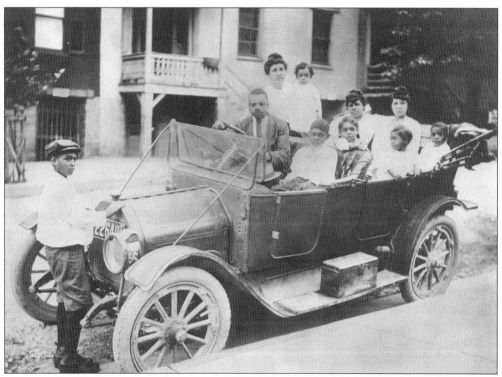

The Dixon family, headed by William and Mary Pitt, is seen in their automobile in the 1920s. Mary is seated behind her husband. The children are as follows: (standing in front of the auto) Hubert; (seated) Lillian, Mabel, Cresa, and Ellen; (seated in the far back of the automobile) Ophelia Pitt, who became a Lockert and the first black public librarian in Nashville. The Dixons were ministers, teachers, grocery store owners, and realtors. Dixon United Methodist Church was named for Rev. William Dixon.

Myrtle McCord Morton was Pleasant Lane's grandchild. Myrtle was orphaned at an early age and her grandmother told her many stories of her life, the conditions under which she lived, and of old customs and traditions, many long forgotten. Myrtle married William Stephen Morton, whose family history has been found in the Gabriel Morton Bible, dating Sellars Morton to 1799. Myrtle was the mother of 13 children, 8 of whom lived to maturity.

Myrtle was a homemaker and community activist. Her daughter Tommie Morton Young is an activist, author, career woman, and mother. Tommie was the first black to ever graduate from Peabody College. She earned a Ph.D. degree from Duke University and was the first and only woman to head the North Carolina Advisory Committee to the United States Commission on Civil Rights. She also founded the North Carolina and Tennessee African-American Genealogical Societies.

ERRATA

Page 14	Monroe Rucker	
Page 23	Helen G. Mays	
Page 48	Black Bottom	
Page 52	"began in Black Bottom"	
Page 83	"from" South Nashville	
Page 93	Annie Pearl, James' wife	
Page 97	Hortense Jones	
Page 104	Fisk University	
Page 128	Seay-Hubbard United Methodist Church. Nashville: The Church	

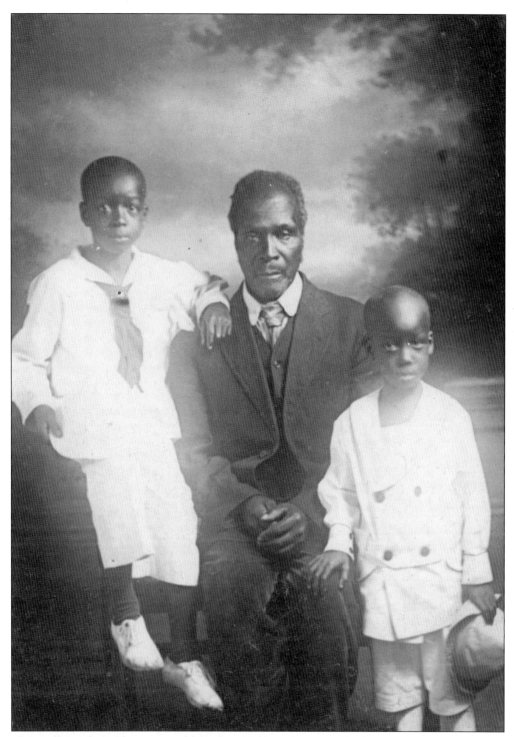

The Halls and McClains are old and proud south Nashville families. George McClain, the grandfather of Fannie Hall Williams, was born in 1840. He is seen here with two young cousins.

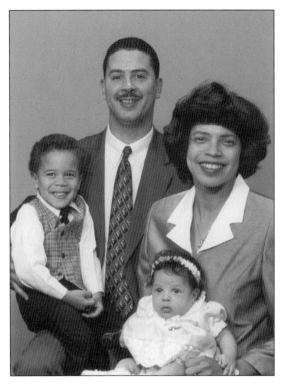

Pamela Young Sanders is Tommie Morton Young's daughter and Pleasant Lane's great-great-granddaughter. She is married to John Sanders, an executive with Sears Company. They are the parents of Sara Ashley and Jonathan Thomas. John and Pamela's children—along with Jacob, Pleasant's father, and two other levels of great-grandchildren through Myrtle's daughter Fredella Morton Taylor's great-great-grandchildren—bring the Lane family line to nine readily identifiable generations.

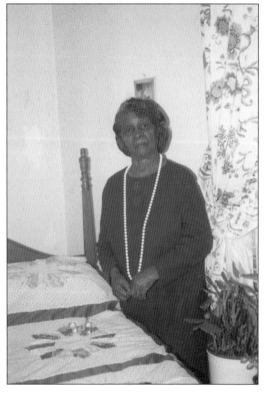

Fannie Hall Williams was born in Hall Town and has spent her entire life in Flat Rock, a local community now known as Woodbine. Now 107 years of age, Miss Fannie, as she is affectionately called, was 94 when she posed beside quilts she has made over the years.

Still living independently at age 107, Miss Fannie has received numerous awards and honors for her community activism. She is shown here after receiving a plaque for her work encouraging a community center for her neighborhood. Miss Fannie has served as a practical nurse and cook, and is recognized as a competent seamstress. She organized sewing clubs for ladies in her community. Fannie Williams Boulevard is named in her honor. As this publication goes to print, Miss Fannie is near death as a result of a fire in her home.

Richard Henry was born a slave in 1843 and became a minister. His interest in religious education and the development of black ministers led to the founding of the National Baptist Publishing Board. He also established the One Cent Savings Bank. His son Henry Allen followed in his father's footsteps and held various posts including the presidency of the Globe Publishing Company. Dr. T.B. Boyd is presently CEO of the National Baptist Publishers Board.

Pleasant Lane was born in 1820 and died in 1905. She was said to have been free and kidnapped in North Carolina and spirited away to Marshall County, TN, where she spent the last years of her life. The last heard of her husband was that he was in Canada. Pleasant was the mother of 16 children, and was an ancestor of Tommie Morton Young.

Great-grandchildren of Tempie and Monroe Rucker, freed people and early residents of Nalensville Road, are seen in this picture. At the far right is Orrin, who graduated from Fisk, became regional director for Fisk Alumni Affairs, and is a financial consultant. At the far left is Mack, who graduated from Tennessee State University and became the first black salesman for a major dairy company in the South. The Ruckers owned a dairy business at one time.

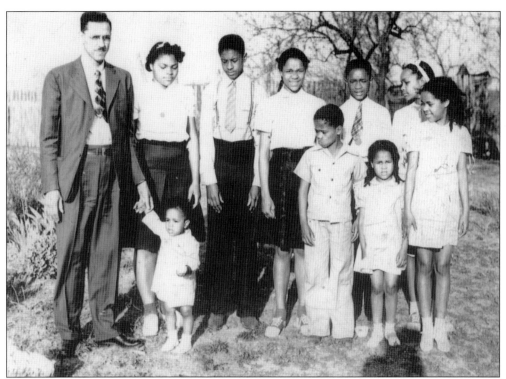

Walter Swett is seen with his children and niece in this late 1930s photo. The children, from left to right, are as follows: (front row) Morris, Austin, Suzanne, and Lethia; (back row) Frances, Walter Jr., Edith, Bennie, Constance, and Jewell. The Swetts ran a family business in groceries and restaurants.

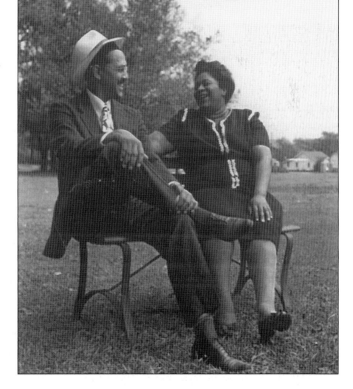

Susie and Walter Swett were partners in marriage and business. These two entrepreneurs raised a large family and ran two successful businesses. Susie originally came from the Mt. Zeno community.

15

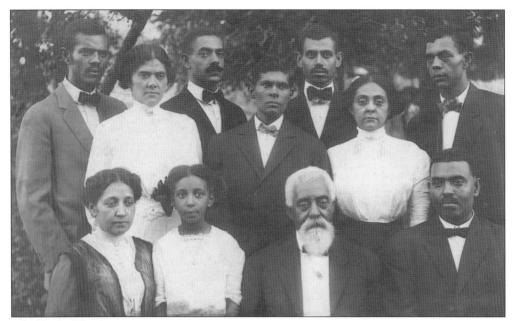

In 1917, the family of Moses McKissack II, son of the founder of the famous McKissack & McKissack architectural firm, posed for this photograph. From left to right are the following: (seated) Amanda (Mrs. William Deberry), Charlotte Deberry, Moses McKissack II, and Moses McKissack III; (standing) Calvin, Mary Francis, (Mrs. Samuel Utley), Willo W., Tommie E., Abraham M., and Annie (Mrs. A. Maxwell and Arthur).

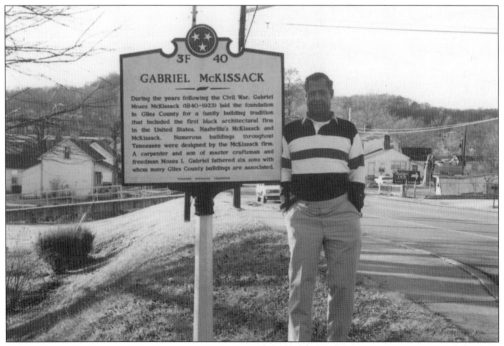

A historic marker in Giles County, TN, acknowledges the work and contributions of Gabriel McKissack.

The youngest to the oldest descendant sons of Moses II are seen in this photograph. From left to right are William Deberry, Samuel Marshall, Calvin Arthur, Lemuel Harlin, Gabriel Andrew Moses, and Lewis Winter.

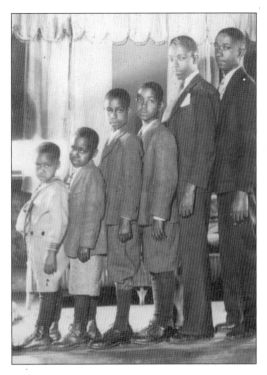

Robert Churchwell was the first black reporter to be hired by a major southern newspaper when he joined the staff of the *Nashville Banner* in the late 1940s.

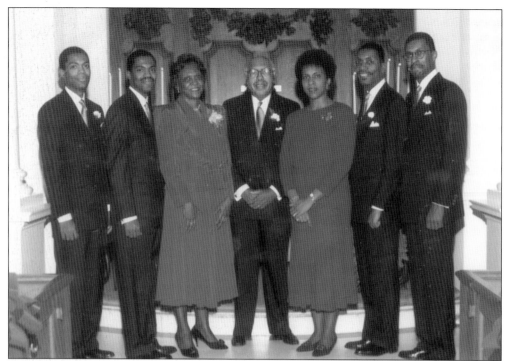

The east Nashville family of Robert and Mary Churchwell poses for a photographer. From left to right are twins Keith (a cardiologist) and Kevin (a pediatrician), Mary, Robert, daughter Marisa (an educator), Robert Jr. (who holds a doctorate) and Andre (a cardiologist).

Mary Churchwell was born a Buckingham. From left to right, Buckingham siblings Theopolis, Albert, and Eloise, with their mother Viola (far right), stand in the front yard of their Bell Buckle home.

Robert Churchwell Jr. is seen in his arms of his grandmother, Mrs. Johnnie Chruchwell.

The Churchwells are associated with the Seay-Hubbard Methodist Church. Rev. Isom Churchwell, Robert Churchwell Sr.'s grandfather, is seen at far right in the photograph. Robert Sr.'s father, Jesse, worked on the railroad.

Flem Otey (pictured) succeeded I.E. Green in the grocery business that was established in 1904. The grocery, located at Eighteenth and Jefferson, was a popular place to shop. Richard Otey, a brother, became director of Boys Work for the National Sunday School Board and was a pioneer in Boy Scout Leadership. Inman, another brother, is a minister and administrator at Tennessee State University, having served as chaplain in military service.

Edith Otey, the wife of Flem Otey, was a social activist and teacher. The Otey women have been teachers, business partners, and counselors at Fisk and Tennessee State Universities.

Dr. J.B. Singleton Sr. was an early graduate of the Meharry Dental School. He and his family lived on Jefferson Street. Singleton's son followed his father into the field of dentistry.

This comfortable house on Jefferson Street was the home of Dr. J.W. Singleton Sr. near the turn of the 20th century.

Nashville had a significant number of families with a large number of children. Rachel Hudson (widow of William) poses with her nine children in Nashville, TN. All nine of the children are alive and well, and hold or have held significant posts in work and private living. Seen in this photograph are Benjamin F. Hudson Jr., Margaret McEwen, Robert Jr., Rae Watkins, William R., Mabel Hudson Tipton, Ola G. Hudson, Andrew A., and Charles R. Hudson.

Family reunions are held by many Nashville families. Here, the Hudson family gathers at Spruce Street Baptist Church on the occasion of the announcement cupboard being dedicated to the memory of Viola Hudson.

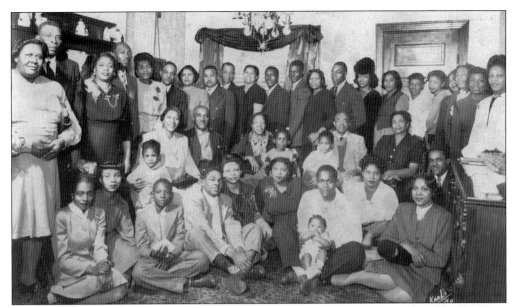

The Hayes family is a typical Mt. Nebo Hill family. Having migrated from Mississippi over 70 years ago, the Hayes settled on Twenty-fifth Avenue North near Mt. Nebo Church. The family motto is "work and worship." The Hayes clan gathered in St. Louis for this 1946 family reunion. Staunch members of Mt. Nebo, there have been three Hayes deacons and numerous other officers at the church.

John Galloway was a long-time principal of Nashville's famous Pearl High School. His son Alfred chose the trades as his life's work, and was the first licensed black plummer in the city. Alfred is shown here with his siblings and nephew. From left to right are John, Sadie Galloway Johnson, Ruth Johnson Manson and John Richard (the child), Mary G. Davis, and Helen G. Mays. The daughters followed in their father's footsteps and were teachers.

Charles Dungey Sr. is a descendant of James Dungey, a free black man who ran the tollhouse on Charlotte Pike. In her *Reminiscences*, Emma Bragg notes the history of the free Dungeys and how they came to own the log cabin that was used as the tollhouse where fees were collected for entrance into Nashville upon arriving from Memphis. The later Dungey was associated with Deborah's, a popular west Nashville restaurant.

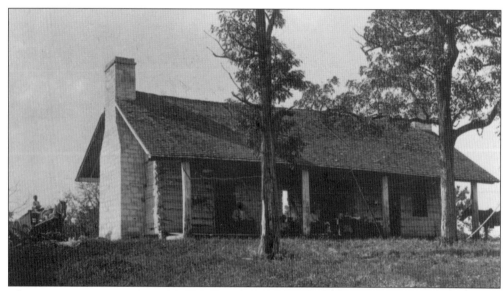

African Americans in early Nashville were both bond, free, and quasi-free. Some blacks lived in nice homes and had reasonable capital. Sarah Estell rented rooms and made a prosperous living as a caterist. Others lived in lean-tos as they were in bondage. Still others, who were slaves, lived in cabins such as this one on the Belle Meade Plantation. The cabin was built in the 1790s by Daniel Dunham. John Harding bought the property in 1807, and added to it. The Hardings lived in the cabin until the 1820s, after which it housed slaves including Bob Green, the head hostler at the plantation. Green continued to live in the cabin until around 1900. (Photo courtesy of Belle Meade.)

The Reddick family, like many residents on Meharry Boulevard, enjoyed a nice home and a clean and pleasant neighborhood. Prior to the coming of the interstate highway network, the community was a highly desirable place to live. In close proximity to the Reddicks were the K. Gardners, the Mayberry sisters, Reverend Bennet's family, principal William Fort's family, pharmacist Bugg's family, and the Allens, Heards, and Harold Wests (a past president of Meharry).

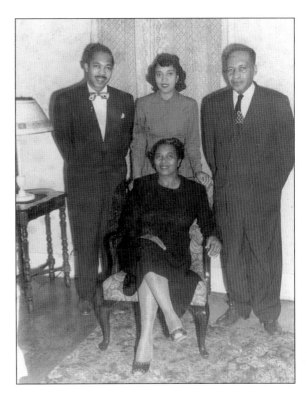

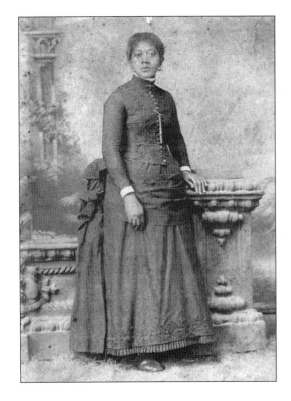

A Lake Providence woman poses in this late-19th-century photograph. She symbolizes the poise and togetherness characteristic of the women of the community.

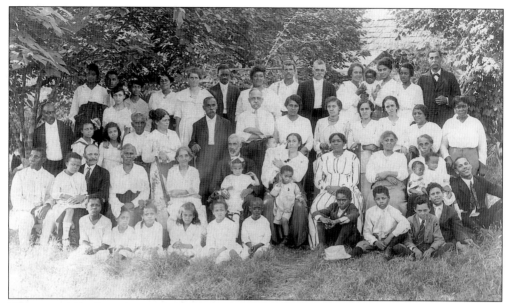

The Carter family gathered for a family reunion photograph on Labor Day, 1917. In the center of the photograph in the fourth row is "Cousin Joe." A freeman in antebellum Nashville, he owned the log cabin visible in the background that was used as a tollhouse to collect fees for entrance into Nashville on Charlotte Pike. The Carter family has deep roots and blood-ties to Belle Meade Plantation. Dr. Emma White Bragg, family historian and psychologist, is seen seated in the photograph in the first row, second from the left.

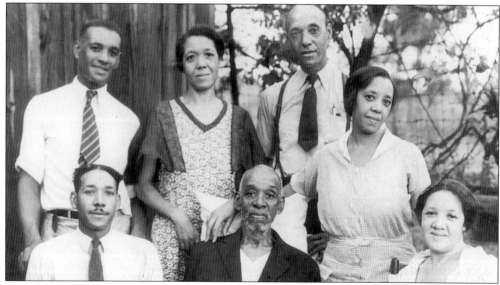

The Spann family is a typical northwest Nashville family that migrated from a small Middle Tennessee community known as Spanntown, which was founded by a white owner who migrated from Virginia. The family settled on a now defunct street called Zollicoffer, near the Mt. Nebo Hill community. Seen in this 1938 photograph and seated in the center of the first row is Harrison Spann, who was born around 1870. He is surrounded by his children. Seven generations of the Spann family can be readily identified.

Surrounding communities evolved following the Civil War, and Lake Providence was one such community. Jonny Collins, a local resident of Lake Providence, poses in this 1920s photograph in his Sunday best. He is seated outside the house he proudly owned.

In 1931 America was experiencing the worst depression in its history. Survival was the goal, and luxuries were hard to find. Yet Nashville pride often found a way. Mrs. Edwin (Lora) Thomas, wife of railroad worker Edwin, is seen in her bid for luxury—a genuine full-length fur coat.

The Louisville and Nashville Railroad Company (L&N) operated a prosperous business with a constant flow of trains in and out of the Union Station. Nashville air quality was referred to as "Smokey Joe." The steam engines, fired by coal, spewed soot and acrid smoke that floated across the city and settled especially in north Nashville. Stable jobs were eagerly sought

after. The railroad offered steady employment and worker benefits such as pension plans for retirement. Edwin Thomas is seen (third from left) with three co-workers as they leave the New Shop at the railroad yard on Twenty-fifth and Charlotte. Thomas worked for 40 years in service at the railroad company.

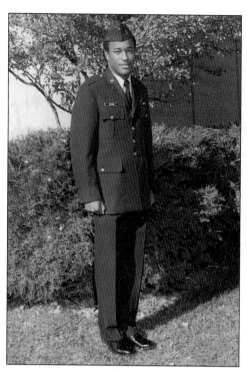

Nashvillians served their country in war and peace. Lt. Col Terrence Spann (US Air Force) is a descendant of Harrison Spann.

Many large homes along Meharry Boulevard (formerly Heffernan Street) were largely obliterated with the advent of the interstate highways in the 1960s. Stable south, east, and west Nashville communities changed with the coming of urban renewal. Cohesion in the black community also experienced decline. In the 1930s Halloween block parties were held on Heffernan Street extending from Eighteenth Avenue North to Twenty-eighth Avenue North.

The old Iron Works Factory on Rolling Mill Hill, long since closed, at one time drew large numbers of black workers who labored in the "sweat shop" of the factory. The factory was located in south Nashville, near Black Bottom and Trimble Bottom. Also in the area was and continues to be the C.B. Ragland Company, which offered jobs to blacks. Jobs in the factory and in the north Nashville and Edgehill fertilizer plants offered higher pay than most jobs for blacks. The fertilizer works used phosphate, which is detrimental to workers' health. But with the money earned, blacks bought modest homes and often sent their children on to high school and higher education, thus breaking the bonds of poverty they had known. The old Iron Works Factory is being considered for regentrification as a condominium complex.

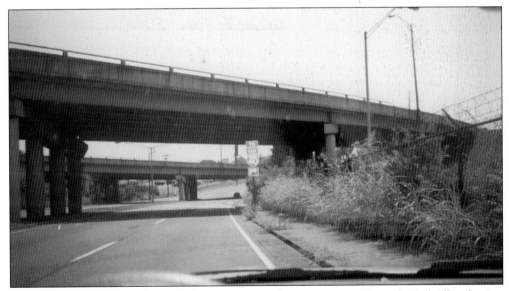

Interstate Highways 40, 60, and 24 cut across north, west, east, and south Nashville, altering these communities forever.

Neat rows of "shot gun" houses with neat yards and plants lined the streets of Trimble and Black Bottom. Many of the homes still stand today. Generations of working-class youth evolved from these communities and went to local colleges, emerging as a viable business and professional middle class.

There were a number of nice homes in areas like Villa Place, where many of Nashville's professional, business, and clerical groups lived. J.D. Chavis lived in this house in Villa Place. As the residents and communities have aged, people are relocating in newer, mixed neighborhoods, and unlike the communities of the past, black unity and solidarity have been altered.

Two

ARTS, CULTURE, AND RECREATION

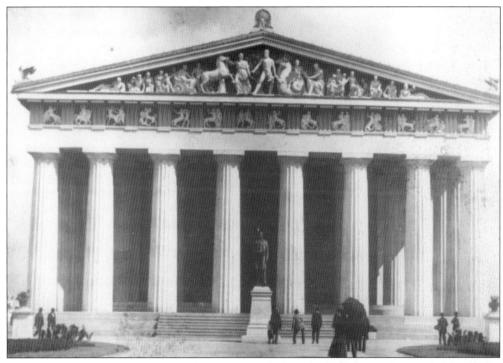

The Parthenon in Centennial Park represented the ideal of the "Athens of the South." Dorcan architecture also dominated early government buildings in downtown Nashville. This ideal coincided with the practices of black Greek letter organizations that pursued scholarship and excellence. Access to Centennial Park for blacks was limited until more recent years.

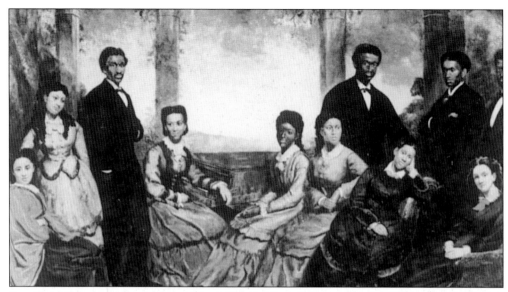

Seated in this portrait are the original Fisk Jubilee Singers, who in 1873 responded to a command performance to sing before Queen Victoria in London, England. From left to right are Mabel Lewis Imes, Minnie Tate, Green Evans, Ella Shepherd, Jennie Jackson, Maggie Porter, Issac Dickerson, America Robinson, Thomas Rutling, Beniamin Holmes, and Georgia Gordon. George Haverhill was the artist.

J.D. "Chick" Chavis was a graduate of Pearl High School and one of Nashville's more popular musicians and bandmasters. Serving as director of the Washington Junior High School Band, he also directed the the Tennessee State College Collegian Dance Group. He was known for his smart style in music. Marcus Gunter was also a well-known musician and directed the Pearl High School Band. He played at such places as the Plantation Club in Murfreesboro, with notable pianist "Blind Jimmy," and with jazz great Don Q. Pullians in the Melody Barons. Pullians also directed bands for the public schools.

Greek letter organizations came to black campuses in Nashville in the 1920s. In this 1950s photograph, members of the Pi Zeta Chapter of Zeta Phi Beta Sorority serve at a tea that honored Josephine Holloway, a pioneer Girl Scout leader and member of the sorority.

Members of the Imperial Coterie Club gather at a meeting at the Eighteenth Avenue Community Center in 1945. The organization is one of the oldest among Nashville's social and civic clubs.

The National Sorority of Phi Delta Kappa, Alpha Beta Chapter, held a Founder's Day

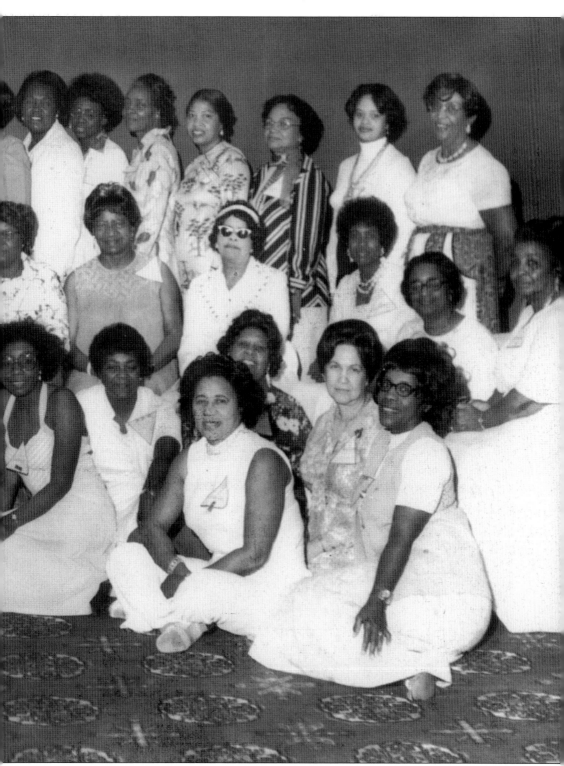

observance in the Hyatt Regency Hotel in 1976. The sorority is made up of teachers.

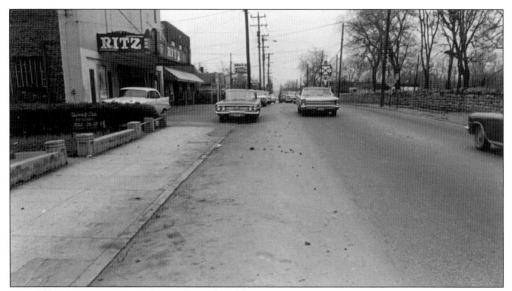

Nashville had movie houses early in the 20th century. The Bijou, Ritz, Gem, and Ace were popular in the 1930s and 1940s. The Ritz, located on Jefferson Street in close proximity to Fisk and Tennessee State University, was the premiere theatre offering first run movies before they "went downtown" to the white theatres. The Bijou was downtown in the black business district and offered concerts and talent competitions. Access to white theatres on Church Street required going down an alley to purchase tickets and mounting a long winding stairway to the "chicken roost," as the black section was called.

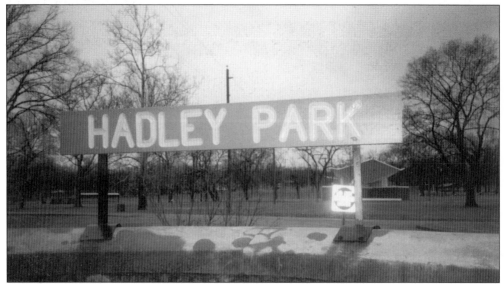

Hadley Park was the first public park opened for African Americans. Nashville's leading politicians and business figures had pushed for parks and playgrounds for black families as well as for a library. The park opened in 1912 on the site of the old Hadley Plantation and may have been named for the former owner, who became a benevolent figure. The park was the center for family outings, sports events, and free movies in the summer. In the 1930s it also offered a kindergarten for neighborhood children.

Arna W. Bontemps was librarian at Fisk University and gained fame as an author. He was the first black president of the Nashville Library Club in the 1950s. His former home is a historic landmark. His daughter Joan married Avon Williams, a noted civil rights attorney.

The Carl Van Vechten Art Gallery at Fisk University dates from 1889, when it was the first gymnasium built at a predominantly black college. In 1942 it came to house a significant collection of art works and was named for noted New York music critic and art collector Carl Van Vechten, who urged Georgia O'Keeffe to donate part of her art collection to Fisk University. Aaron Douglas (1899–1979), considered the father of African-American art, has works housed in the gallery collection. Douglas was a teacher of art and head of the department at Fisk for 29 years, and his murals grace the walls of the old Erastus Cravath Library.

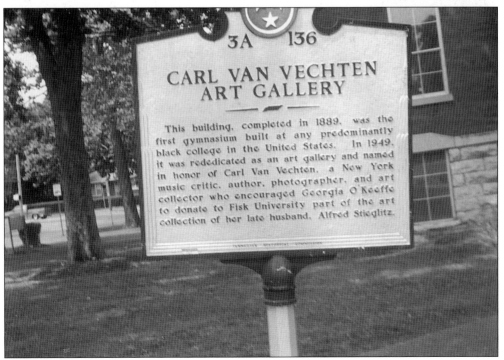

Rev. Alfred Whitlow of the Lake Providence Community was a cousin of William Edmondson, a noted black sculptor and native of Nashville.

African Americans have always cherished their families and their history. Since the release of the book and movie *Roots, Saga of an American Family*, by Tennessean Alex Haley, more and more blacks are seeking to know their roots in history. In 1979, Nashvillian Dr. Tommie Morton Young founded the North Carolina African American Genealogical and Historical Society, and in 1994 she began the Tennessee African American Genealogical and Historical Society (TAGS), Inc., which participated in the National Genealogical Society's 1995 conference in the States. Member Elizabeth Bowman and charter member Frances Johnson are shown here meeting a guest at the TAGS booth.

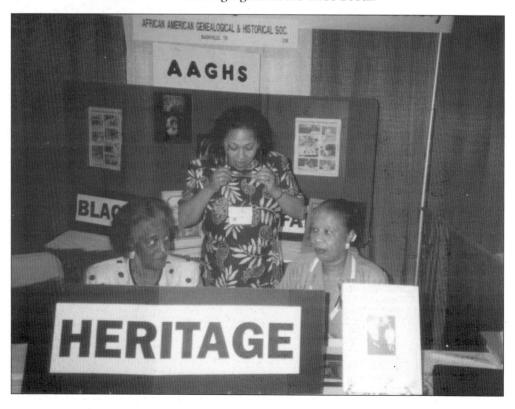

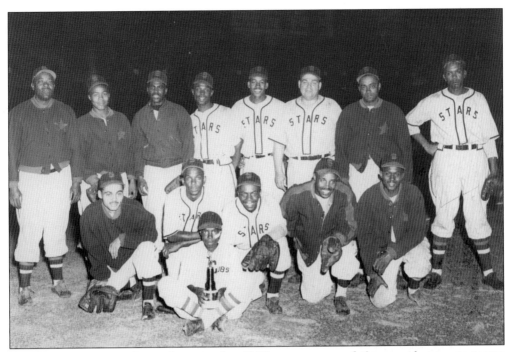

The Nashville Stars, shown here in the 1950s, were one of the popular sports teams in Nashville. The Nashville Vols, who played at the old Sulphur Dell, and local college teams also provided sports entertainment. Enthusiasm for golf produced famous golfer "Ted" Rhodes.

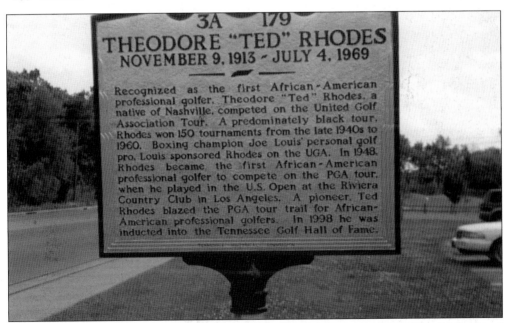

Theodore "Ted" Rhodes was a Nashvillian and the first African American to play professional golf. He opened the door for blacks on the Professional Golf Association tours. The Theodore Rhodes Golf Course on Ed Temple Boulevard is named for him.

Picture postcards were popular in the early part of the 20th century, and Nashvillians took pride in seeing their images in the format. Several black photographers had successful businesses over the years, including the Lay Brothers (1912–1928) and the Andersons (1928–1950s). In later years Gunter Studio was popular. Some blacks patronized the studio downtown in the arcade where picture postcards could be made. Iris Lane Cole, who was born in 1898, posed for this picture postcard.

Thomas W. Talley was an administrator and chemistry teacher at Fisk university. Born in 1870, he became America's first black folklorist and compiled the States' first collection of black folktales.

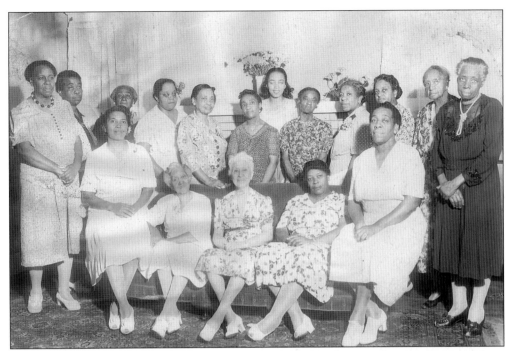

Mary Church Terrell was born into privilege in Memphis, TN, yet she devoted her life to human rights and women's issues. A leading figure in the Federation of Colored Women's Clubs, she was a staunch supporter of the Woman's Suffrage Movement. Tennessee became known as the "Perfect 13," having cast the deciding vote to make Woman's Suffrage a law. In Nashville, one of the federation clubs was named for Terrell. In this 1943 picture, Terrell meets with the club that is her namesake in the home of the Reddicks on Meharry Boulevard.

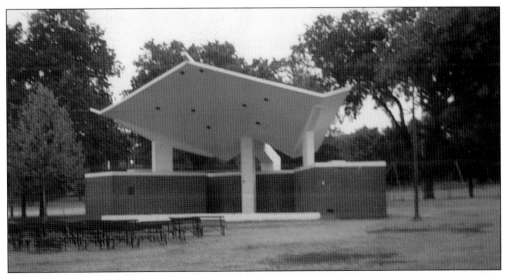

Music in the park is part of the cultural essence of Nashville. This is the rotunda in Hadley Park.

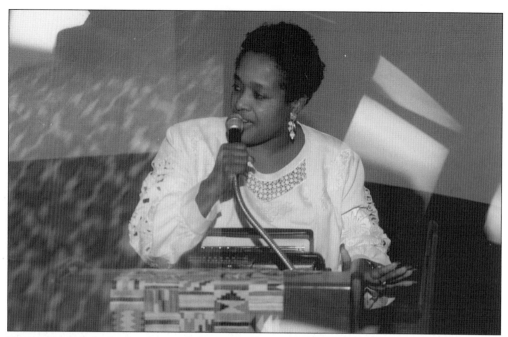

Teresa Hannah is the producer of the Nashville Gospel Productions and has a record label in gospel music. The gospel music industry has become quite innovative. Gospel artists like CeCe Winan and Bobby Jones have entered into big business in the field. Jones performs on the BET television network, and Winan continues with hits and international appearances. *Gospel Today* is a publication for persons interested in the business of gospel music, and the Gospel Music Association is a membership group that promotes new talents. Gospel music is to the black community what country music is to the majority group.

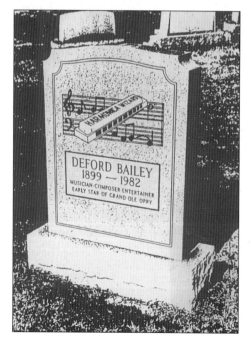

Deford Bailey was a musician and composer and was one of the few blacks to play at the Grand Ole Opry.

Three

EDUCATION

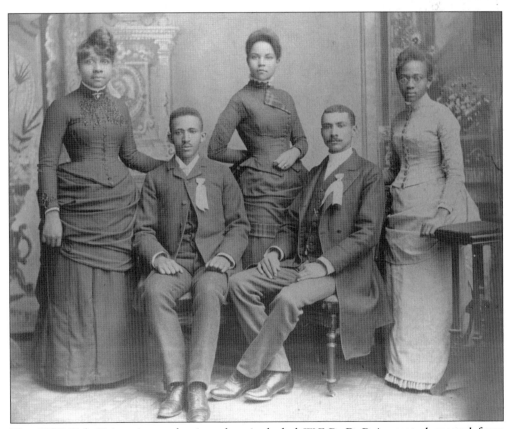

The 1887 Fisk University graduating class included W.E.B. DuBois, seated second from the left.

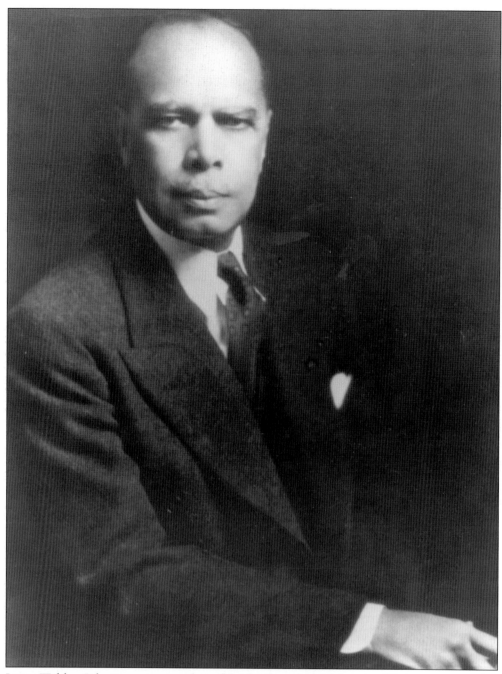

James Weldon Johnson was a member of the faculty at Fisk University. His home near Fisk is a historic landmark. Johnson was also field secretary for the NAACP, and wrote the famous *Negro National Anthem*, or *Lift Every Voice and Sing*.

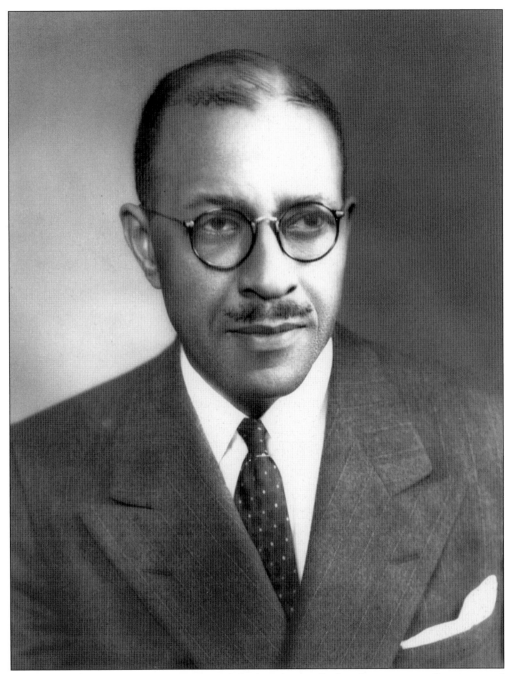

Charles S. Johnson was an imminent sociologist who studied various aspects of poverty and lifestyles among black Nashvillians. Subsequent to continuing protest by Fisk students, and with the urging of activist, graduate, and faculty member W.E.B. DuBois, Dr. Charles S. Johnson became the first black president of Fisk University in 1947.

Richard Henry Boyd had a keen interest in promoting secondary schools in Nashville. He and other members of the Negro Board of Trade persuaded the city government and the mayor to build a new Pearl High School near Fisk University, and the new school opened in 1916. The first Pearl was built in 1887 in Black Bottom.

The third and last Pearl School opened in 1936 at Eighteenth and Jo Johnston Streets. Pearl High School was considered one of the best secondary schools in the nation. Students from outside Nashville often entered Pearl because they were not afforded secondary school training. Until Haynes High School was built in the 1930s, these students had to travel to Pearl. With the coming of integration, Pearl joined with Cohn High School to become Pearl/Cohn. It is located near and on the grounds of the demolished Ford Greene Elementary School and Washington Junior High School. The old Pearl now functions as the Martin Luther King Magnet School.

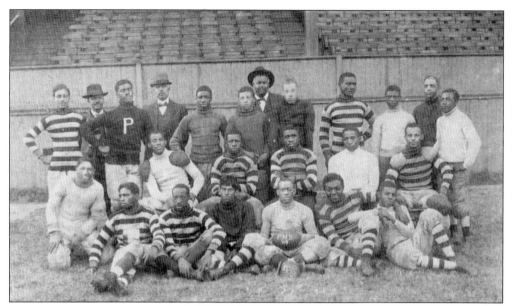

Pearl High had a thriving football team in 1909.

Washington Junior High School was on Twenty-fourth Avenue North. Washington School carried grades seven to nine. However, when Ashcraft School closed, and Ford Greene was not yet completed, grades five to six attended Washington Junior High School. Many students from outlying areas commuted to the school in the absence of provisions for children beyond grade nine.

Cameron School in south Nashville began as Pearl Junior High School in 1924 on Fifth Avenue South. During the 1930s the name changed to Cameron Junior High School. In 1940, the school moved to First Avenue South. Named for First Lt. Henry A. Cameron, it became a secondary school in 1954. With the desegregation of public schools in Nashville, the last high school graduating class was in 1971. Once again it serves the middle school population.

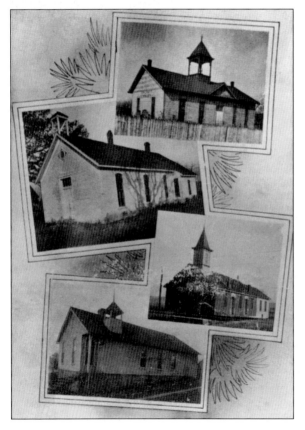

Seen here are some of Nashville's black elementary schools in the 1920s and 1930s.

Edward Temple came from Philadelphia to Tennessee State, where he graduated and left an indelible mark on the school and the sports world. Known as the trainer of champions, he has coached some of the Olympics' most famous and successful athletes. A section of Twenty-eighth Avenue North in Nashville is named Ed Temple Boulevard, for the TSU track coach.

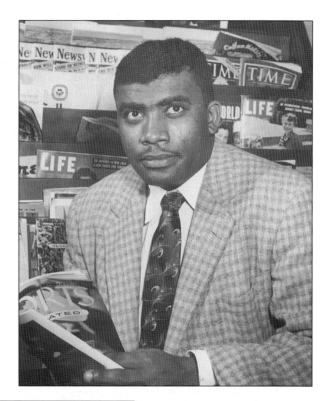

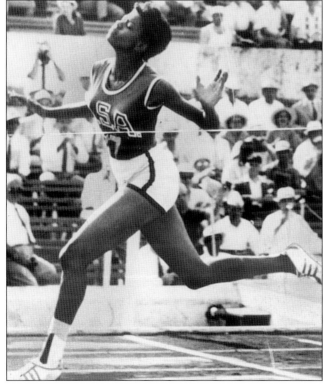

Moving in as lightly as a bird, Wilma Rudolph, Tennessee State University's track star and the fastest running woman at the time, is seen in Rome in 1960 where she won three gold medals for her superb performances. A dormitory at Tennessee State is named for her, as well as a boulevard in Clarksville, TN.

The Meigs School began in Black Bottom, and later moved to east Nashville. Faculty members in 1961 included Chick Chavis (a popular musician in Nashville), Mackie Driver, and William Gupton.

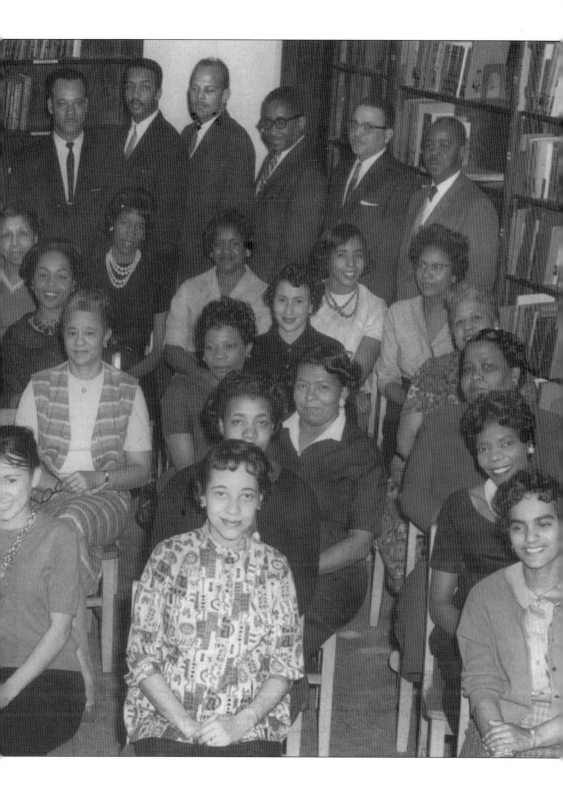

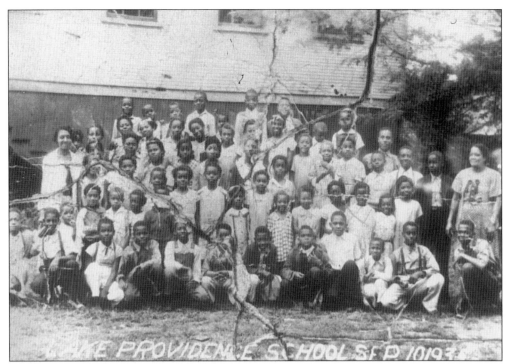

Lake Providence is a community that was settled after Emancipation, when African Americans were displaced and seeking a home. Until the 1950s, when school consolidation became a reality, one and two-room frame schools were common in the outlying areas of Nashville. Children pose in this 1935 school picture.

Ashcraft was one of the old public schools dating back to the early part of the 20th century. It closed in the late 1930s or early 1940s and was replaced by Ford Green School. The children in this 1946 photo competed in an oratorical contest pose on the stage of the old school that became the Nashville Christian Institute (NCI), a private Church of Christ grade school and training institute for preachers.

Clinton Derrick was principal of Haynes School. For years children in such communities as Mt. Zeno, Antioch, Rock City, Flat Rock, and Lake Providence could only go through the eighth grade in the schools in their communities. It was necessary for these children to seek Washington Junior High and Pearl Senior High if they wanted secondary education. Haynes School opened in 1931 and a high school department was added in 1935. William Haynes, an African American, donated the land for the school. Students were not provided transportation to get to school, and Principal Derrick worried about his students.

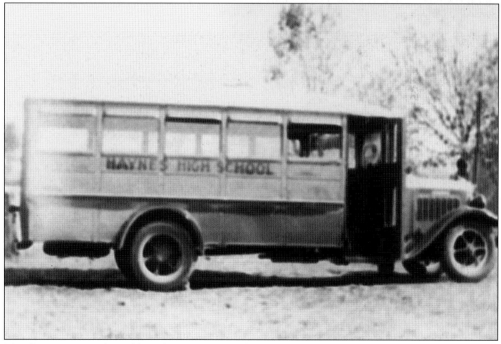

This bus was purchased by Clinton Derrick for the transportation of schoolchildren. When it was time to pay for the bus, parents and the community rose to the occasion.

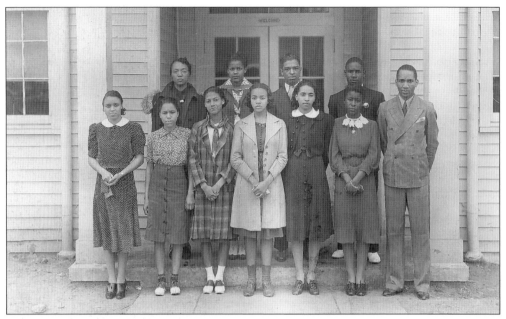

Principal Derrick poses with students of the high school department at Haynes School. Henry McClaron stands in the back row, third from the left. The school has had a checkered past. A street widening project on Trinity Lane threatens to impact the school, which now serves lower grades only.

Although equipment and supplies were limited and classrooms often cramped in the county schools, Haynes did an effective job in training students. Standing at the far right in this photograph is school supervisor Amanda Derrick, wife of principal Clinton Derrick.

William Jasper Hale was president of Tennessee's first state-supported institution of higher education for blacks. In 1910, at discussions of opening normal schools in Tennessee, a black state-supported school was suggested. The evolution of the school was slow because of a lack of funds. Henry A. Boyd tried to stimulate interest in a black normal school in Nashville, but Nashvillians were slow to respond with finances. By 1909, wealthy black leaders were pushing for a bond to help pay for a school. W.J. Hale, a school principal, favored Chattanooga as a site for the school, but Benjamin Carr and Henry A. Boyd promised an additional $40,000 in bonds and Nashville became the city of choice by the state board of education. Hale's educational training was limited, but his connections and political acumen were well established. Although he weathered some difficult times in developing the school, he remained the head of the school and later was called president from its opening until 1943. Robert E. Clay, assistant to the State Agent for Negro Schools, helped Hale deal with legislators through his persuasive and affable personality.

In 1915, Julius Rosenwald began contributing money toward building rural schools for black children in Tennessee. Robert E. "Daddy" Clay was appointed an assistant to the state agent for negro schools. Clay was active in Booker T. Washington's National Negro Business League. An affable man, he was of great benefit to William J. Hale, the first president of Tennessee A & I College. Clay eventually joined the staff of Tennessee A & I and was known affectionately as "Daddy Clay." He led the Sunday school on campus and was well liked by the students and faculty alike. The Sunday school was named Robert E. Clay Sunday School, and a building was named for him at TSU. Ivanetta Davis, widow of Walter S. Davis, the second president of Tennessee A & I (TSU), said that her husband also relied on the judgement and wisdom of Clay, who served under Davis.

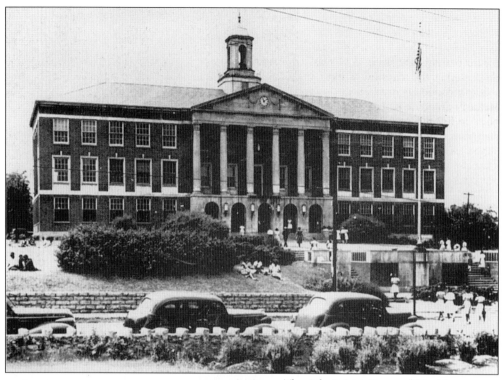

The Administration and Health Building at TSU was erected in 1932. The building included administrative offices, classrooms, a swimming pool, and the Little Theatre.

Walter S. Davis became the second president of Tennessee A & I State College. A graduate of the school, he received a doctorate from Cornell University. The college experienced significant growth under Davis and became Tennessee State College under his administration. The W.S. Davis Building at TSU and W.S. Davis Boulevard are named in his honor.

Pictured here is Dr. Matthew Walker. On March 7, 1970, Meharry's first major construction for outpatient care since 1931 was dedicated as the Matthew Walker Neighborhood Health Center. A Meharry graduate in 1944, Walker became full professor and chairman of the department of surgery, having initiated the post-graduate program in surgery at the college in 1941.

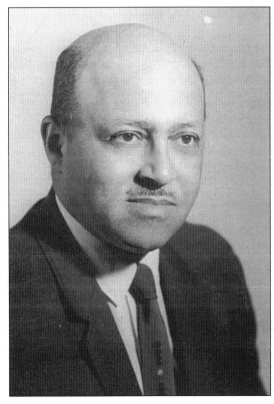

E. Perry Crump, M.D., was on the faculty of the Meharry Medical College and headed the pediatrics department. He often traveled to Africa to study black children.

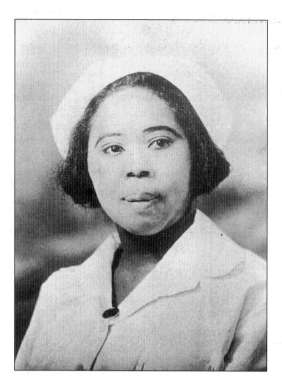

Hulda Margaret Lyttle graduated from Meharry's Nurses Program in 1912. In 1916 she became director of nurses training, and in 1921 superintendent of Hubbard Hospital. Lyttle Hall, a nurses residence at Meharry, was named for her.

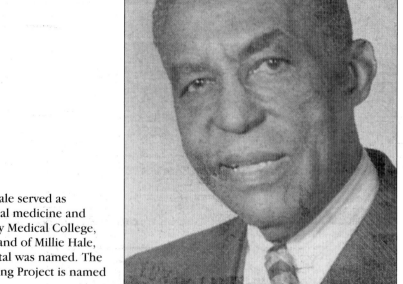

Dr. John Henry Hale served as professor of clinical medicine and surgery at Meharry Medical College, and was the husband of Millie Hale, for whom a hospital was named. The Henry Hale Housing Project is named in his honor.

Samuel Freeman, M.D., was the son-in-law of J.H. Hale, being married to the Hale's only daughter, Mildred. While Millie was trained as a nurse, she taught English at Pearl High School until her retirement.

The Millie Hale Hospital was organized in 1916. It occupied the second floor of the Hale residence, the first floor being living quarters for the Hale family. The hospital issued a periodical called the *Hale Hospital Review and Social Service Quarterly*.

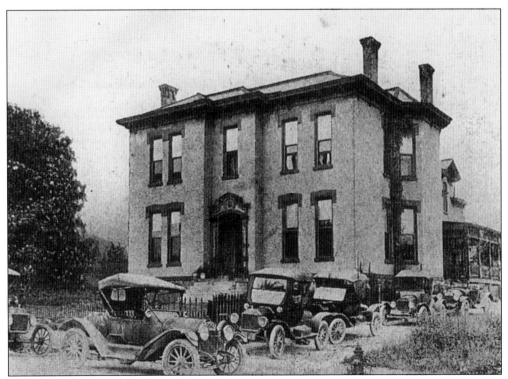

Donley H. Turpin served as professor of prosthetic dentistry at Meharry's Dental School. He is credited with bringing innovations to the program.

Robert F. Boyd (no relation to R.H. Boyd) came from Giles County and served in a number of jobs to help himself through medical school at Meharry. He went on to do post graduate work at the University of Chicago and later returned to Meharry to teach. A highly intelligent and versatile man, he had a thriving medical practice and opened Mercy Hospital, which Meharry used as a teaching source. Only two other private medical facilities existed at the time—the Wilson Clinic and Millie Hale Hospital. Boyd entered politics and became a heavy investor in black business interests.

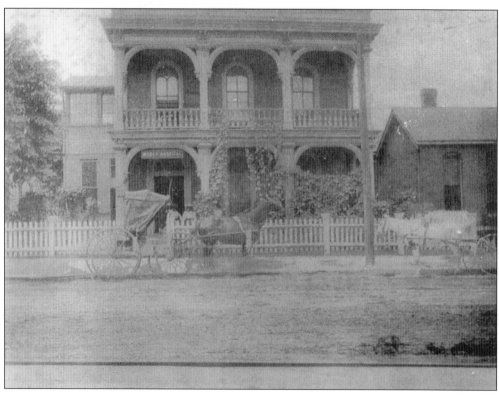

Dorothy Brown graduated from Bennett College and Meharry Medical College. She was the first black woman to be board certified in surgery in the South. She went on to have a distinguished career as a state legislator. She also established a precedent in becoming a single adoptive mother.

Harold West, Ph.D., became the first president of Meharry Medical College on November 6, 1952. He was professor of physiology at the college and held an impressive record in research and fund-raising.

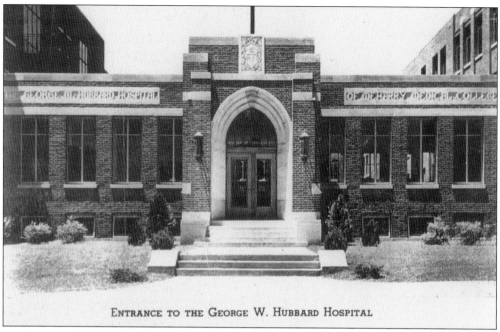

ENTRANCE TO THE GEORGE W. HUBBARD HOSPITAL

The George W. Hubbard Hospital of Meharry Medical College was an impressive entity in its day. Hubbard Hospital has closed and Metro General Hospital has taken its place as a teaching agency for Meharry Medical College.

Tennessee State University installed honor societies early in its existence that encouraged excellence in scholarship. The Alpha Kappa Mu Honor society was founded on Tennessee State University's (then Tennessee A & I State College's) campus by then dean George W. Gore. Gore later became president of Florida A & M State University and interim president of Fisk University. Current TSU president Dr. James Hefner brought the Phi Kappa Phi Honor Society to the campus in 1993. Dr. Tommie Morton-Young is seen as she is inducted into the society as a distinguished alumnae.

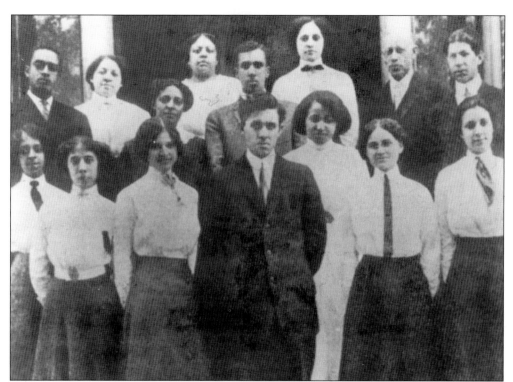

After a faltering start, and lukewarm support from the legislature, African-American leaders such as J.C. Napier and R.H. Boyd assured the opening of the Tennessee normal school for "Negroes" by securing bonds. The school opened in 1912 on a rocky farm in northwest Nashville with William Jasper Hale serving as principal and later president of the institution. The first faculty of Tennessee State University is pictured here.

Ralph Boston was a gold medal winner in the 1960s Olympics, bringing pride to his alma mater, Tennessee State University, and the nation.

The J.C. Napier School was named for the noted black leader in Nashville. Generations of south Nashville children attended the school, which is located in what was once called Trimble Bottom. Many of the school's alumni are well into their eighties. The J.C. Napier School, J.C. Napier Homes (the first public housing complex built by the city), and the J.C. Napier Playground are in close proximity to each other. J.C. Napier had considerable influence in Nashville and blood-ties to the white owners of the profitable iron works on Rolling Mill Hill, located not far from Trimble Bottom.

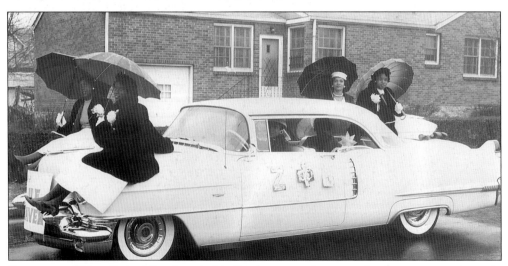

Tennessee State University has held its homecoming parade for many years. As community/school functions continue to decline, the annual homecoming parade remains a community affair. Local schoolchildren, organizations, and other entries participate in the parade and the community comes out to share in it. In this 1958 photograph, Ann Caldwell of Ann's Tea Room drives her car in the parade, which lined Meharry Boulevard. Three women students from the campus and a faculty advisor are also visible.

Four

PUBLIC AND SOCIAL SERVICES

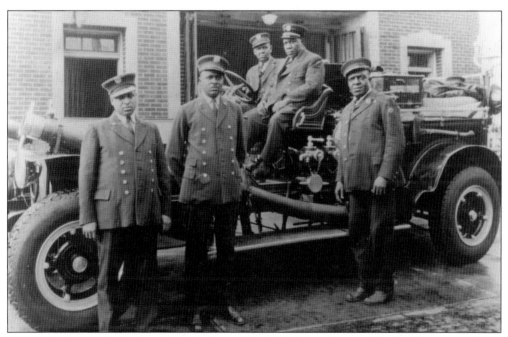

Engine Company #11 was originally Engine Unit #4, located in east Nashville on Woodland
Street. It came about under the urging of city councilman J.C. Napier. Charles Gowdy was
appointed captain of the black fire company. The company earned praise for its bravery in
fire fighting. In 1966 the company moved to north Nashville and became Engine Company
#11. Several persons elected to public offices once served as firemen, including Robert
Lilliard and Willis McCallister.

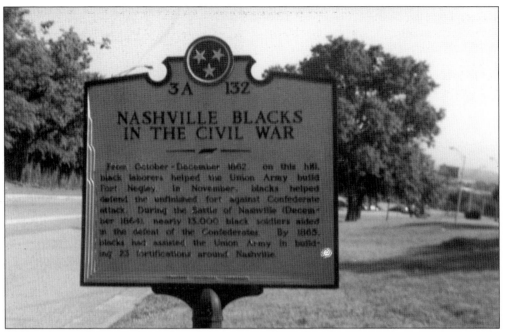

Black Nashvillians' role in the Civil War is noted in this historic marker at Fort Negley.

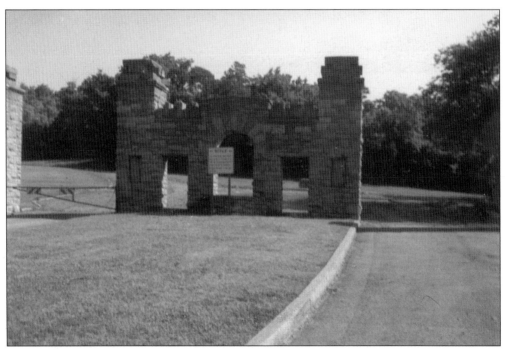

The European-style Fort Negley, the stronghold of Captain J.S. Morton, who held the Confederate forces at bay, was built by black men and constructed of stone, logs, earth, and railway iron. For a time the fort fell into decline but it has since been repaired.

Mrs. Ophelia Pitt Lockert was born in 1902 into the Pitt family. She was the first black public librarian in the city of Nashville, and lived to be 96. She was the mother of several successful children and related to the Dixon and Pitt families.

It took the influence of Nashville's leading black personalities, including the Negro Board of Trade, to get this Negro Branch Library opened in 1916. It continued to serve the public until 1969. The Hadley Park Branch of the Public Library opened in the 1950s.

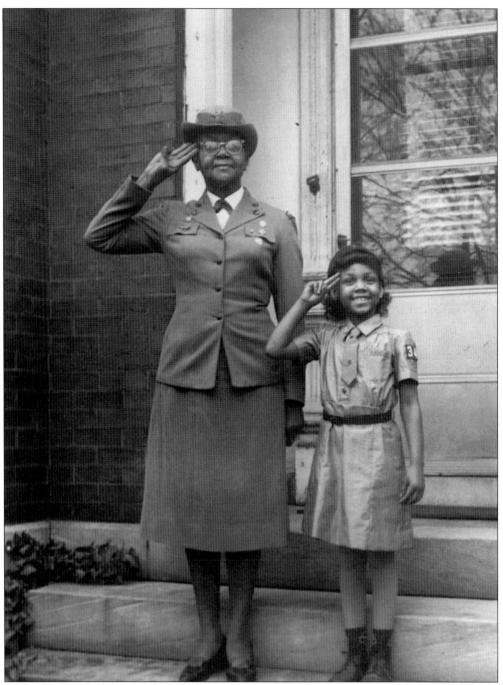

Josephine Holloway was the daughter of a Methodist minister and chose social work as her profession. While working at Bethlehem Center, she observed the need for a girl's organization with national connections. After being put off subsequent to her queries about such an organization, she met personally with Juliette Gordon Low, a wealthy Georgia widow and founder of the Girl Scouts, and made her case. Holloway became the leader of the first black Girl Scout troop in Nashville.

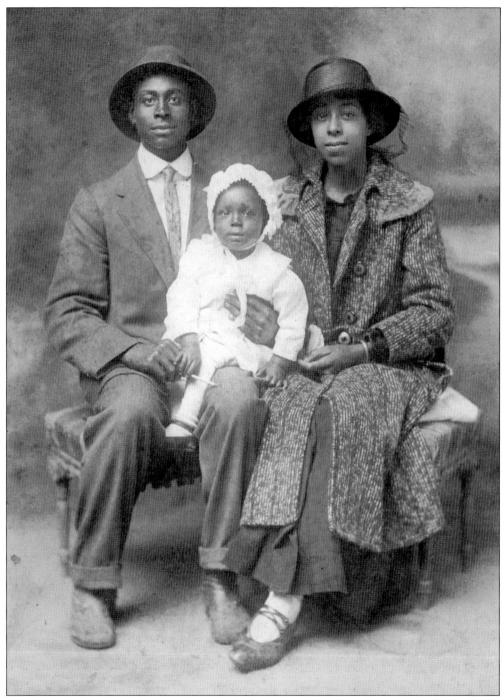

Roy Owens and Arie Baker Owens sit with their son Roy Howard Owens in the Nashville Union Station as they wait for the train that will take the husband and father off to camp and World War II (November 1917). This family, like thousands of other black families, endured as their sons, husbands, and fathers marched off to war to fight for a democracy that had not fully become a part of their lives.

African-American men who worked in the pullman car industry on the railroad were often educated and cultured men. While they traveled their wives kept the home fires burning and many maintained well-established social and public lives. The Railway Employees Protective Society was organized February 12, 1905, by Humphrey Bowling, and maintained sick and death benefits for the members. Later a Ladies Auxiliary was founded.

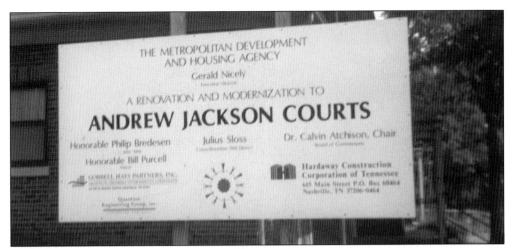

While many blacks enjoyed nice homes in Nashville, other areas were depressed and slums persisted. Slums had sustained since the depression of 1890. The New Deal was to sponsor two public housing projects—one was the Andrew Jackson Courts for blacks. Some slum landlords resisted the housing project, but in the summer of 1935 the Andrew Jackson Courts went into construction near Fisk University and a prosperous black neighborhood. The housing project was a thing of pride. Ministers and teachers lived in Andrew Jackson Courts and in the days before widespread low-cost decent housing it was a pleasant addition to the community. J.C. Napier Courts was the first public housing unit for blacks sponsored by the Nashville Housing Authority. Located in what was once called Trimble Bottom, the complex was named for James Carroll Napier.

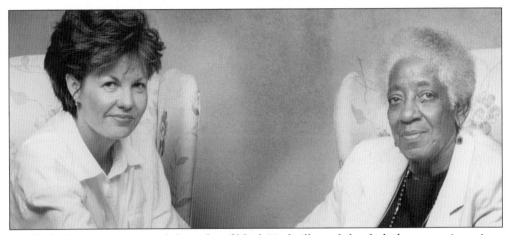

"Self-help" has long been a philosophy of black Nashville and that help has come in various forms and from diverse sources. Laura Buck McCray (right, seated with a United Methodist Church representative) came to Nashville in later years, but made an impact on the community in a way that will not be forgotten. A lay leader in the Edgehill United Methodist Church, she began a hot meal program for 80 to 100 homeless people every Tuesday and Friday. Every facet of injustice was McCray's concern, and she participated in demonstrations for worthy causes from Atlanta to Washington, D.C. She was recognized by CBS Television before her death in 1988. Zulee Ursery, another person from outside Nashville, came to the city shortly before the civil rights struggle. She has been a staunch supporter of demonstrations and efforts in instilling pride in black children.

Pearl Bryant is a well-known church leader, musician, counselor, and club woman. She served for many years on the faculty of Pearl High School, and as state president of the once influential Federation of Colored Women's Clubs. The federation was founded in 1896, and the National Council of Negro Women was an off-shoot of the federation. The club's many members were able to bring about change in varied ways, including influencing city leaders to establish a school for girls. Frankie Piece was president of the federation at that time, and used her considerable influence to accomplish her goals.

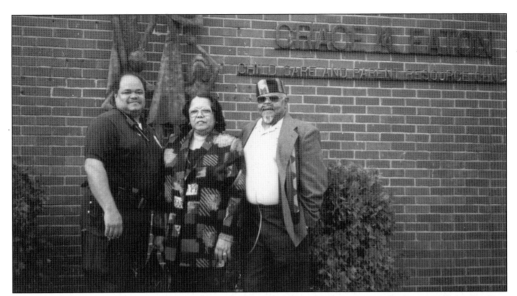

The Grace M. Eaton Child Care and Parent Resource Center was founded in 1926 as the first non-profit child-care organization in Nashville. It was established for the purpose of serving low-income, inner-city children and families. The idea for the center came from Lizzie Kelly, a probation officer and teacher at the Fireside School. The Fireside School of the late 1800s was a program supported by Grace M. Eaton, a wealthy Baptist missionary who visualized mothers teaching their children valuable lessons of life at the "fireside." Kelly approached Eaton, who purchased the first building for the center, and it was named in her honor. The present quarters of the Eaton Center on Pearl Street formerly housed the Blue Triangle YWCA.

African Americans have fought in all of the wars of the United States. Jeffrey Lockelier, a free black Nashvillian, fought in the War of 1812 and is buried in the City Cemetery. Preston Taylor fought in the Civil War, as did William Morton and James Dungey. Black men joined the fighting forces of World War I and anticipated great change when they returned after offering their lives for their county. Instead, a rash of violence was perpetrated against blacks following that war. When World War II came, men like Roland B. Morton and Curtis Hayes of northwest Nashville joined the forces and engaged in battles in the Philippines. In war and peace, African Americans have served in the military forces.

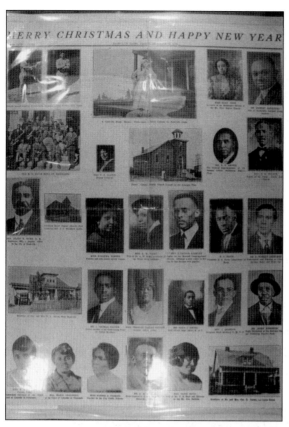

The *Nashville Globe* was an unbridled voice that spoke to the black community about finances, investments, social conditions, social life, and about the matters of black life and living. It was also a medium for cultural communication. The Christmas issue was a pictorial directory that was eagerly awaited each year

Frankie Pierce was a dynamic force in the Federation of Colored Women's Clubs, and an effective politician. In 1921 she founded the Tennessee Vocational School for Colored Girls and served as its first superintendent. Pierce was a supporter of the Woman Suffrage Movement, and before the Civil Rights Movement she led her club members in a march on city hall to protest segregation. She proved to be before the time, for she lost her club members.

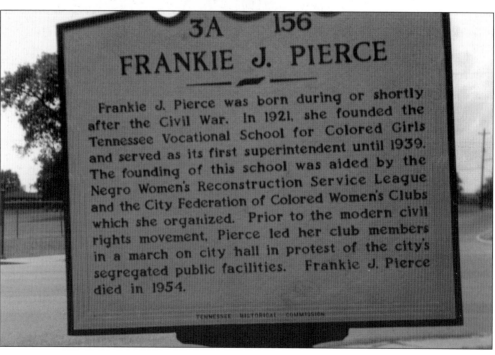

3A 156
FRANKIE J. PIERCE

Frankie J. Pierce was born during or shortly after the Civil War. In 1921, she founded the Tennessee Vocational School for Colored Girls and served as its first superintendent until 1939. The founding of this school was aided by the Negro Women's Reconstruction Service League and the City Federation of Colored Women's Clubs which she organized. Prior to the modern civil rights movement, Pierce led her club members in a march on city hall in protest of the city's segregated public facilities. Frankie J. Pierce died in 1954.

TENNESSEE HISTORICAL COMMISSION

In 1948, Mayor Thomas Cummings appointed five African-American apprentice policemen: Theodore Gant, John Wesley Smith, Will Latham, Herman L. Paskett, and Otis Willis. Chief of Police Griffin and Commissioner Mays established zones in which the black patrolmen would operate. Emmett H. Turner, a member of the Metro Police Force, was named as the first African American to head the Nashville/Metropolitan Police Department, 48 years later.

Immaculate Mother High School was the first Catholic school for blacks in Nashville. The school was founded by Mother Katherine Drexel of Sisters of the Blessed Sacrament and closed in 1952. St. Vincent Academy now operates as an elementary school for black children. Sister Sandra Olivia Smithson, a native of Nashville, is a graduate of the school. Sister Sandra is the founder of Project Reflect, a think tank for serving the poor.

The Blue Triangle YWCA was a significant institution in the lives of black women from the 1920s through the 1950s. It was a place for social, educational, and recreational activities. Its programs reached out to girls in nearby depressed areas and offered hope and opportunities. The Top Ten Club of the "Y" met in 1970 in this picture. The activities of the club included fellowship and services.

Project Hope is an outreach effort founded by Sister Sandra Smithson, a graduate of the first black Catholic school for African Americans in Nashville. The project serves the Nashville poor with educational programs and spirituality missions.

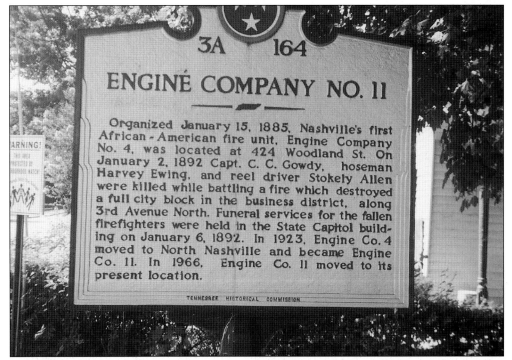

3A 164

ENGINE COMPANY NO. 11

Organized January 15, 1885, Nashville's first African-American fire unit, Engine Company No. 4, was located at 424 Woodland St. On January 2, 1892 Capt. C. C. Gowdy, hoseman Harvey Ewing, and reel driver Stokely Allen were killed while battling a fire which destroyed a full city block in the business district, along 3rd Avenue North. Funeral services for the fallen firefighters were held in the State Capitol building on January 6, 1892. In 1923, Engine Co. 4 moved to North Nashville and became Engine Co. 11. In 1966, Engine Co. 11 moved to its present location.

TENNESSEE HISTORICAL COMMISSION

Black firefighters in Nashville have a distinguished record. This historic marker on Eighteenth Avenue North cites the bravery of black firefighters.

Operated by blacks, the Bethelehem House was financed by the Woman's Council of the Methodist Episcopal Church, South. The house sponsored wide-ranging programs for youth. Aided by social work trainee students from Fisk, Bethlehem House later became known as Bethlehem Center, providing domestic training, gymnastic facilities, programs, and the first "colored" Girl Scouts, South.

Sallie Hill Sawyer, a black woman, in 1907 approached the Methodist Training School and urged that it extend its services to poor blacks in Nashville. Sawyers, a Fisk graduate, was a member of historic Capers Chapel and persisted in her urging until 1914, when a separate settlement for blacks was established at Tenth and Cedar Streets. Mother Sawyer, as she came to be called, served as housemother until her death in 1918. Bethlehem Center has expanded to include another center and its programs have broadened over the years. The center at Fifteenth and Charlotte stands across the street from Capers Chapel CME Church.

Five

RELIGION AND RITUALS

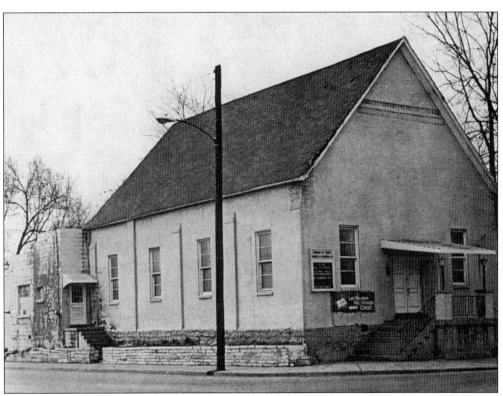

Seay Chapel began as St. Mary's Chapel and later became the Seay Chapel United Methodist Church around 1874. It was located at the corner of Green and Fairfield Streets in south Nashville. Hubbard Chapel, named for George W. Hubbard, the founder of Meharry Medical College, merged with Seay Chapel to form the Seay-Hubbard United Methodist Church. This congregation had close ties with Meharry Medical College when it was located in south Nashville. In the 1930s the congregation worshiped in the old Meharry Auditorium when the college relocated to north Nashville.

In 1921, a grateful public built this house for retiring Dr. George W. Hubbard, who founded and headed the Meharry Medical College for 44 years. The house is still in use and serves as a parsonage for the Seay-Hubbard Church.

The Capers Memorial Christian Methodist Episcopal Church began as the "African Mission" of the white McKendree Methodist Episcopal Church. After preaching to slaves for many years, a commodious brick house was erected near Sulphur Springs for black church members. In 1851, Nashville's black Methodists purchased a lot at Hynes and McCreary (Eleventh Avenue North) Streets to build a church. In 1887, the congregation erected a church at Twelfth and Church Streets. In 1924, the property was condemned to make way for the Church Street viaduct. In 1925, McKissack and McKissack designed and built the present church on Fifteenth Avenue South. The church was significant in helping in the founding of Lane College and has worked with the Bethlehem Centers. Its present location is across the street from Bethlehem Center.

Rev. Larry Thompson founded the Lake Providence Missionary Baptist Church in 1868 and the church served as a beacon for the struggling Lake Providence Community. The membership today continues to increase and outreach programs serve the community.

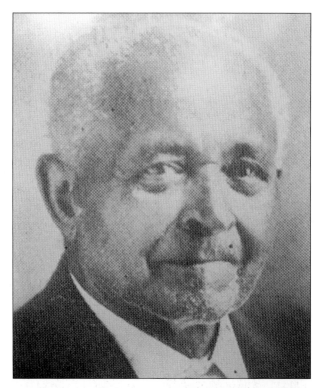

Fairfield Baptist Church, located in what was once called the Trimble Bottom, produced the famous Fairfield Four and has ministered to the community for over 100 years. Mt. Ararat Baptist Church grew out of Fairfield. Meharry Medical College students once worshiped at the church before the college moved to north Nashville.

Rev. Enoch Fuzz, pastor of Corinthian Baptist Church, is a minister committed to outreach ministry to the surrounding community. He also hosts a radio program.

Spruce Street is one of Nashville's early black churches. Founded in 1848 it was originally a mission of First Baptist Church. It had as its pastor one time Rev. Nelson Merry, Nashville's first black ordained minister. Spruce Street fell in the path of the Capitol Redevelopment Project and relocated from downtown to Twentieth Avenue North.

Sunday afternoon activities at Corinthian and many Baptist churches prior to the 1970s included teas, anniversary observances, and annual sermons. Rev. J.W. Pitt was one of Nashville's more popular black preachers, having served as pastor at a number of churches; his annual sermons drew a large attendance. Rev. W.S. Ellington, pastor of First Baptist Church, east Nashville, chose the *Prodigal Son* as the text for his annual sermon. *The Eagle Stirs Its Nest* and *Horse Pawing in the Valley* were among the popular texts for annual sermons.

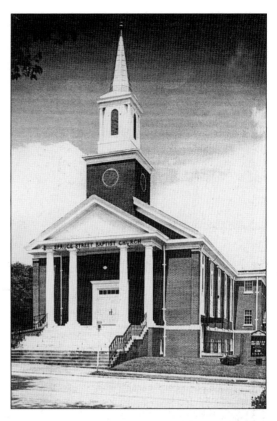

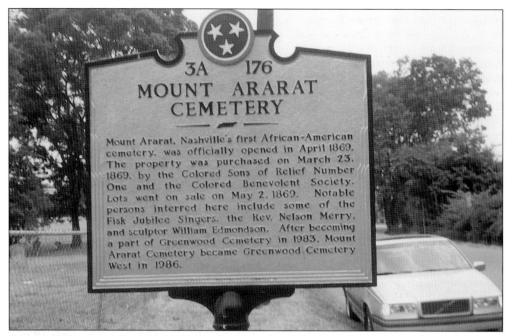

Mt. Ararat Cemetery for African Americans dates back from 1869, when the Colored Sons of Relief Number One and the Colored Benevolent Society purchased the land. In 1983 the cemetery became a part of Greenwood Cemetery. Notable blacks are buried in the cemetery, including former Fisk Jubilee singers, sculptor William Edmondson, E.W.D. Issac, and Rev. Nelson Merry (the first ordained black Baptist preacher in Nashville).

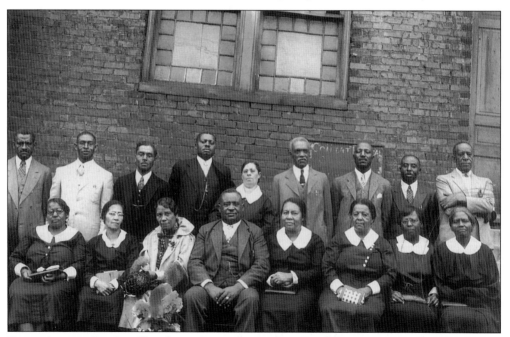

Kayne Avenue Baptist Church was once located at Twelfth Avenue South. The church leaders (deacons, deaconesses, and trustees) pose in 1935 in front of the church.

Rev. Jordan Douglass Chavis Sr. was born in 1862, and was a distinguished figure in educational and religious circles. Having served as president of Bennett College in Greensboro, NC, he was also dean at North Carolina A & T State University. The family moved to Nashville and he became dean of Walden University, district superintendent in the United Methodist Church, and pastor of Seay Chapel before its merger with Hubbard Chapel. Hubbard Chapel was named for George W. Hubbard, founder and head of Meharry Medical College. In 1921 an appreciative public raised funds and built a retirement house for Hubbard, and it is called the Hubbard House. The house is presently used by the Seay-Hubbard United Methodist Church as a parsonage. Reverend Chavis was the father of musician J.D. "Chick" Chavis Jr.

The Tennessee Legislative Black Caucus recognizes the role that the black church plays in every facet of African-American life. Cognizant that support of the church or lack of it can determine an election, Mrs. Carlotta Stewart Wilson was the year 2000 recipient of an award from the caucus that recognized her tremendous contributions to her church and community. Representative Henri Brooks takes the leadership for the African-American Church Day on the Hill.

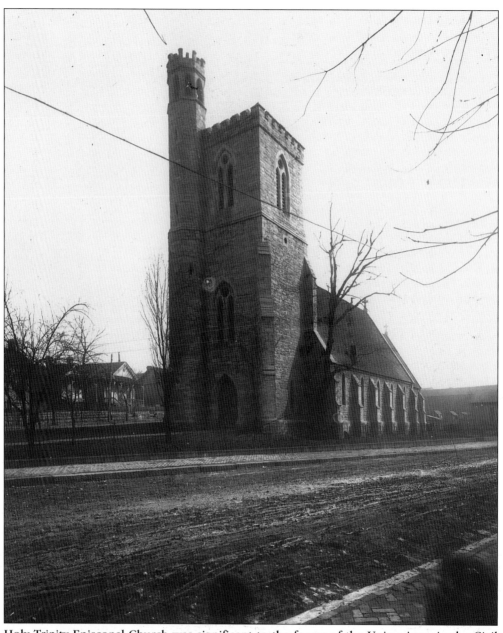

Holy Trinity Episcopal Church was significant to the forces of the Union Army in the Civil War. It hid ammunition for the forces and cared for the federal wounded. It is now a predominantly black church with members from across the city.

Six

Profits and Entrepreneurs

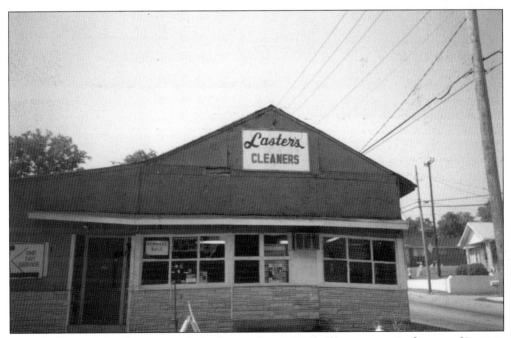

Laster's Cleaners has been a staple in the northwest Nashville community for over 60 years. Mrs. Louise Allen and her son Clarence Laster operated the cleaners until their deaths. The business is now said to be operated by other Lasters.

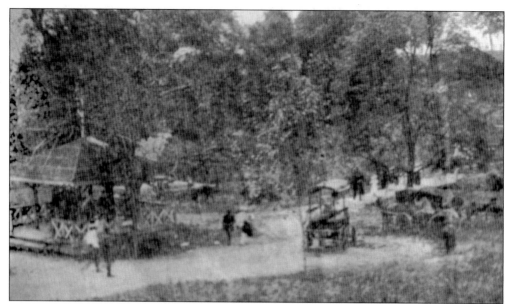

Greenwood Park was founded by Preston Taylor and was considered one of the nicest parks in the area. Taylor, who headed the largest undertaker establishment in the city, envisioned a place where families could gather after church for recreation and inspiration. He sought to bypass local ordinances that required blacks to use city parks under segregated conditions. He was instrumental in getting Hadley Park established and supported the Napier Playground efforts. The Preston Taylor Public Housing Complex is named after him.

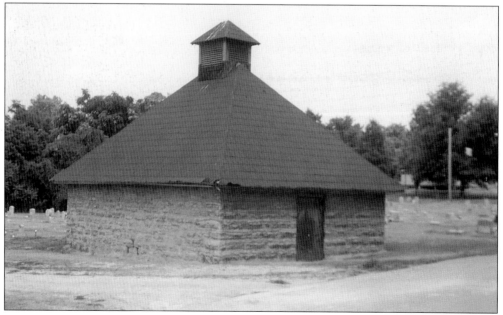

The Casket Building still stands at Greenwood Cemetery. The founder of the cemetery, Preston Taylor, was a versatile and enterprising man. A preacher, community activist, investor, and undertaker, he designed and made caskets in the building on the site of the cemetery.

Subsequent to the transportation boycott of 1905, and the failure of the Union Transportation Company (an attempt by blacks to circumvent the Jim Crow law requiring segregated seating on public transportation vehicles), as many blacks as possible purchased their own mode of transportation. "Jitneys" were an unlicensed mode of public transportation and were available for those who could not afford a taxi and chose not to ride the public street cars. Old and large cars like this one were used as jitneys.

This house has stood for over 70 years. During the 1930s, and before the street was widened and traffic was a problem, this structure served for a time as a "goodtime house." In such houses food, drink, and dance could be had for a small fee. A red light burned on the porch of the house as a signal that it was a place for a good time. Jobs were few and far between during the Depression years and a variety of means were created to make a living. House rent parties were common as well.

Printing and publishing seems to be in the blood of Nashvillians. Among the popular printers of the past few decades were Darden, on Jefferson Street, and Hemphill, who in later years moved to east Nashville. New technology in publishing and printing has found African Americans with dealerships providing a variety of printing and copying services.

Entrepreneurial families flourished in Nashville. James Garret and his son worked at the Gulf gas station owned by Garret at Eighteenth and Jefferson. One of the first blacks to receive a dealership from a major oil company, Garrett also had an Exxon on Clarksville Highway.

Annie Pearl, James's wife, kept the books for the dealership and served as cashier.

Tom Garrett, the father of James, was in the business of breeding horses. He held certification in this area.

Walter and Susie Swett opened their first restaurant in 1954 and subsequently built a larger facility at Twenty-eighth and Clifton Avenue. Swett was the first African American to open a food service at the new Farmers' Market.

Morris and David Swett are second generation owners and operators of Swett's famous "soul food" restaurant. The Sweets opened their restaurant in 1954, but had operated a grocery earlier.

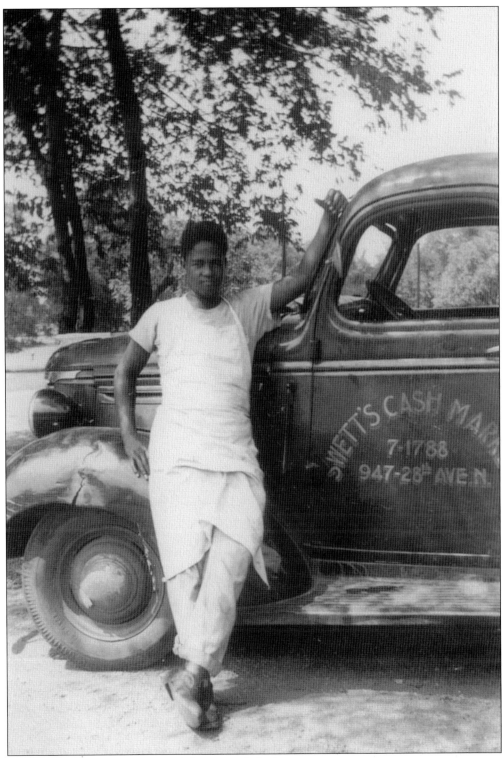

Austin Swett drove the grocery delivery truck for his parents.

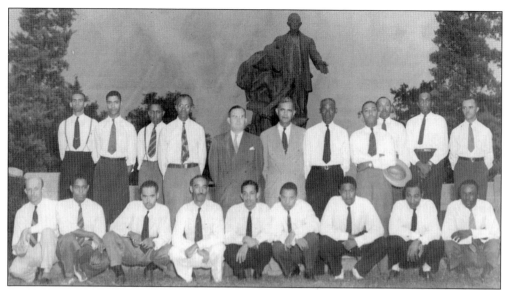

Staff of the project of the McKissack and McKissack Prime Contractor for the 99th Pursuit Squadron Air Base and Training School at Tuskee is shown here. Over 7,500 workers were employed in the project with Calvin McKissack serving as superintendent.

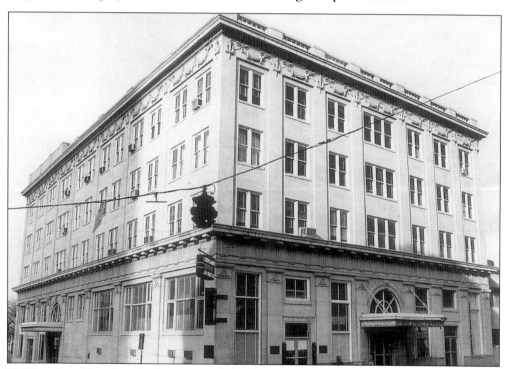

McKissack and McKissack, the nation's first black architectural firm, was commissioned to design and build what became the Morris Memorial Building. Once the pride of the now defunct black downtown business district, the Morris Memorial Building remains on Charlotte Avenue, where the Sunday School Publishing Board operates and continues to offer cafeteria services to the public.

Brown Belle Beverages had a short life in Nashville. Touted by the "Brown Bomber," Joe Louis, it did not compete successfully with Double and RC Colas. The 1940s effort was another of the enterprising ideas that Nashvillians pursued.

Brown Belle Beverages

The Best That Can Be Made.

Drink

Boga Chic

Big Boy Cola And Pep-Up

Morning, Noon And Night
For Real Delight

Sodas True Fruit Flavors

Brown Belle Bottling Company

311-313 Jo Johnston Ave. Phone 5-7962

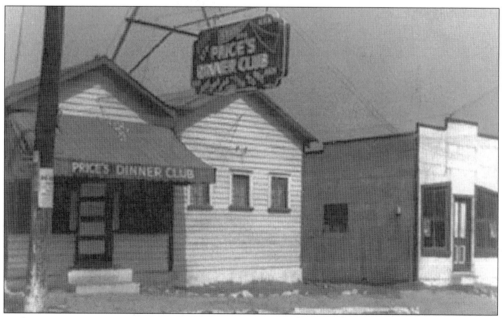

Earl "Po" Price operated a college hangout/restaurant in the 1950s on land now occupied by Tennessee State University. Later he operated Price's Dinner Club on Jefferson Street. The College Crib is a successful operation that is run by Price's widow, Hortense Jones, and his two sons.

Kossie Gardner was born Carthenous Crosby, but was apprenticed to the Gardner family and he took their surname. A popular undertaker in the 1940s and 1950s, Gardner had a keen mind and good business sense. He bought and owned the Masonic Temple Building downtown. Gardner also introduced new housing in the development of Gold Coast, founded Hills of Calvary Cemetery, and maintained a farm and a dairy business.

Kossie Gardner's Gardner Building, once known as the Masonic Temple, is located in the thriving black business district.

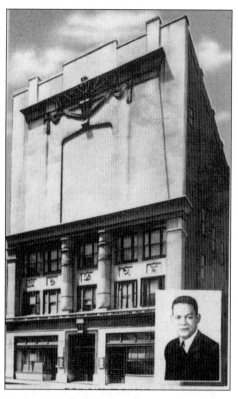

The first house in the Gold Coast Community was begun by Kossie Gardner in 1952. These homes consisted of large ranch-style structures beginning on Hydes Ferry Pike. The development was among the moves that professional and business blacks made from Jefferson Street and nearby thoroughfares. Haynes Height on Whites Creek Pike was another development that brought impressive homes to the Nashville African-American buyer.

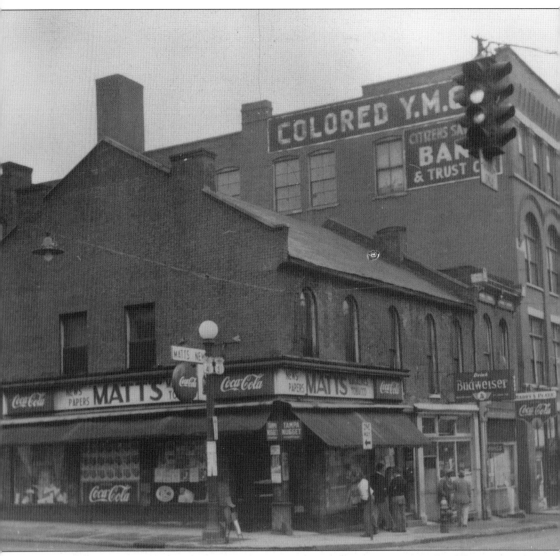

Fourth Avenue and Deaderick Street was one entrance to the "black wall street" where major black business and professional offices were located. The colored YMCA, the Citizens Saving and Trust Company Bank, the Sunday School Publishing Board of the National Baptist Convention, the office of the *Nashville Globe* (Nashville's premiere black weekly newspaper), People's Pharmacy, the Bijou Theatre, the club New Era, and numerous office complexes were also located in this strip.

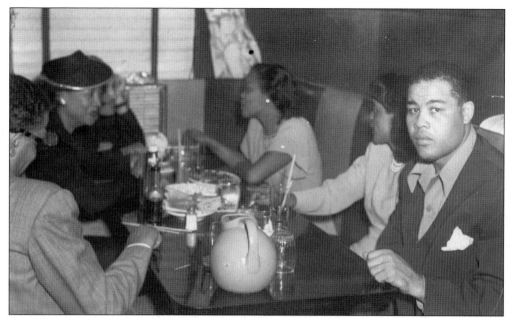

Nashville was said to be an "open town" in the 1940s and 1950s, and night clubs and dance halls did a brisk business. Live entertainment from personalities who became famous was often a part of an evening's outing in Nashville. The Black Hawk, New Era, and Delmorroco (Del) were popular sites. Theodore Acklen's Del saw many famous names and faces visit the establishment on Jefferson Street. Here Joe Louis takes time out to dine at the Del in 1942.

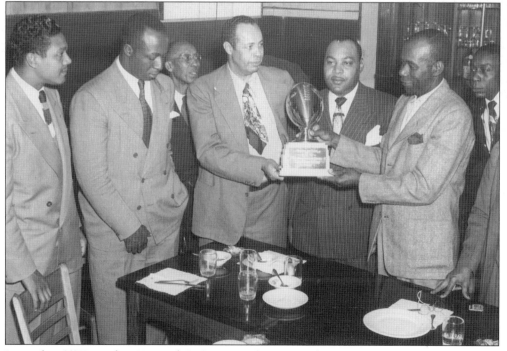

Legendary TSU coaches Howard C. Gentry and Henry Arthur Kean presented an award to a recipient at an affair at the Delmorroco.

Acklen drew on his sports connections and celebrities such as Roy Campanella and Jackie Robinson stopped at Acklen's place, the Delmorroco, in 1943. Ivory Joe Hunter, Larry

Darnell, and other popular entertainers who have become famous provided amusement for the customers over the years.

Prices Pharmacy on Jefferson Street was a popular drug store and meeting place. Located near Fisk and Meharry, it also offered a soda shop and lunches.

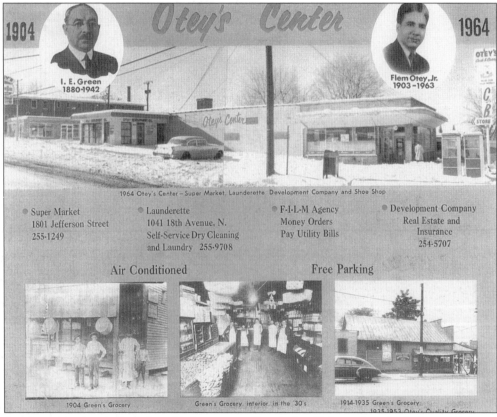

Otey's enterprises included multiple services during the 20th century, including I.E. Green opening a grocery at the turn of the century.

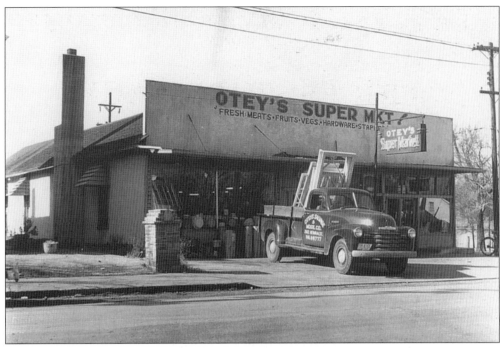

Otey's operated several groceries and was a north Nashville staple.

The Eldorado Motel was founded by William Otey and has outlived other black lodging establishments such as the Teresa and Brown's Hotel.

Tennessee Bean was a major figure in the Universal Life Insurance Company's operation in Nashville. Competing with male agents and without an automobile, she pounded the streets of north Nashville collecting from policy holders.

The Union Protective Assurance Company was founded in Memphis but had a thriving operation in Nashville. Staff of the Nashville office met in 1962 with Toby Pursley serving as assistant manager. The founder of the company, a Mr. Whalum, met the fierce competition in the insurance field in an unusual way. Having a powerful and pleasing singing voice, he often performed at churches such as Mt. Zion Baptist, and having sung would pass out his business cards. A significant number of persons would be so moved by his voice that they would sign up as policy holders.

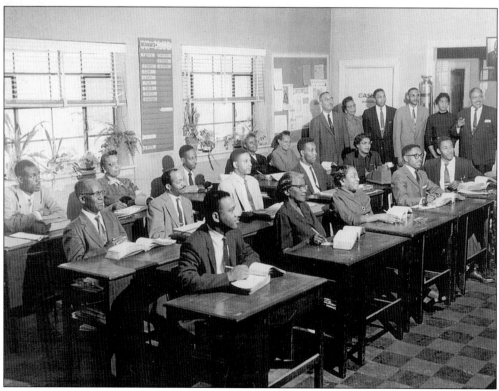

Publisher of the *Tennessee Tribune* and *Contempora* magazine, Rosetta Miller-Perry is the only women heading a successful newspaper in Nashville. She is the founder of the Greater Nashville Black Chamber of Commerce and the Anthony Ceburn Journalism Center. Other women in the media publishing field include Delores Black, owner of the *Black Yellow Pages*. Nashville's *Urban Journal* and *Nashville Pride* are two other popular newspapers owned and operated by African Americans.

Relative newcomer to Nashville Anthony J. Ceburn (seen above) is president and CEO of multimillion dollar health care management firm Med Access. Another newcomer, Sam Howard, for a time successfully operated the Phoenix Health Care Management System and was a radio station owner. Howard served as chairman of the Metro Chamber of Commerce.

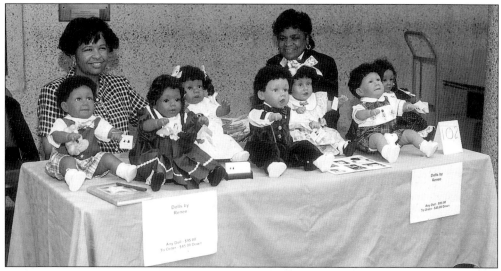

Until the Civil Rights Movement, black children's dolls were hard to find. The National Baptist Publishing Board in its efforts to engender pride in black youth, encouraged "black dolls for black girls." The Eskind Department Store on Jefferson Street was one of the few, if not the only, white merchants that sold the dolls.

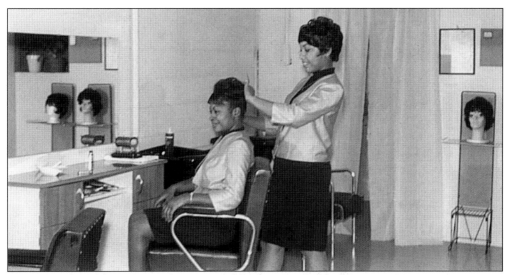

The beauty and barber industry has been a mainstay in the black economy. Beauty services for black women in Nashville came shortly after Emancipation when a black woman working as a maid in a white beauty shop picked up the trade and later began her own services. Beauty culture has allowed many black women operators the chance to become successful business women and entrepreneurs. Rose Brown in 1966 deposited $25 with a builder to reserve a space in the new facility for what she hoped would be her first beauty shop. She opened the House of Charm on South Seventh Street and maintained a successful business. A barber shop was located adjacent to her shop. Brown graduated from Joyce's Beauty School, which was owned by a woman. Mrs. L.E. Bowman and Mrs. Gladys Norris also owned successful beauty shops and schools of cosmetology. Johnson's School of Cosmetology also operated in south Nashville. With the coming of technical schools funded by the government, private beauty and barber schools declined in number. "Your Barber Shop" was a popular site at Twenty-eighth and Jefferson Streets.

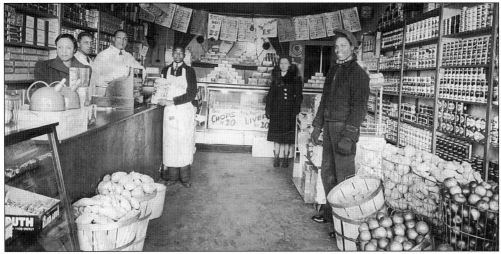

Thomas' Grocery operated in the 2700 block of Jefferson Street. The Thomases were not related to Edwin Thomas, but are often cited as the "drugstore" Thomases, as the family had drugstores and a number of pharmacists.

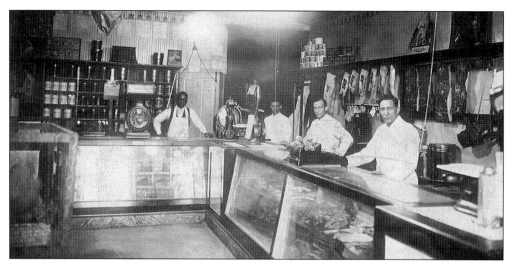

In south Nashville entrepreneurs and business pioneers Thomas M. Ewell and Romulus Cotton were brothers that operated the Cotton Cafe, Grocery, and Meat Market at the corner of Twelfth Avenue and Edgehill Street. With the advent of urban renewal the Cotton Cafe moved to Thirteenth Avenue South and Edgehill. Operating as business partners for over 40 years, the Cotton Brothers enterprises gave employment to many young people and was a source of food for many south Nashville residents during the lean years of the Depression. The community cited the brothers for their business acumen and humanitarian interests. Tommie Cotton Manning is a niece of the Cotton brothers.

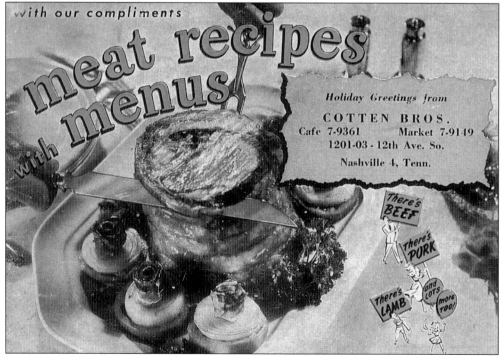

The Cotton Brothers Cafe had a reputation for serving delicious food. The owners published this book of meat recipes and menu items as a compliment to their customers.

Seven

POLITICS AND PROTESTS

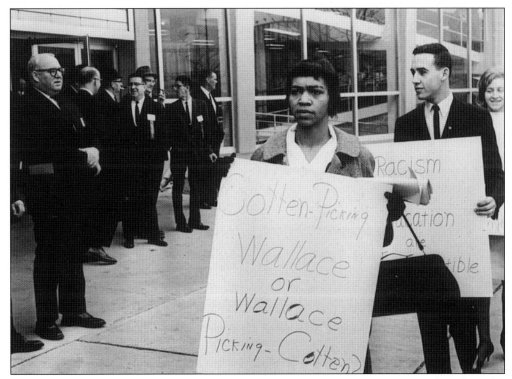

Demonstrations are often used by college students to get a point across. In this photo bi-racial efforts help to facilitate the protest.

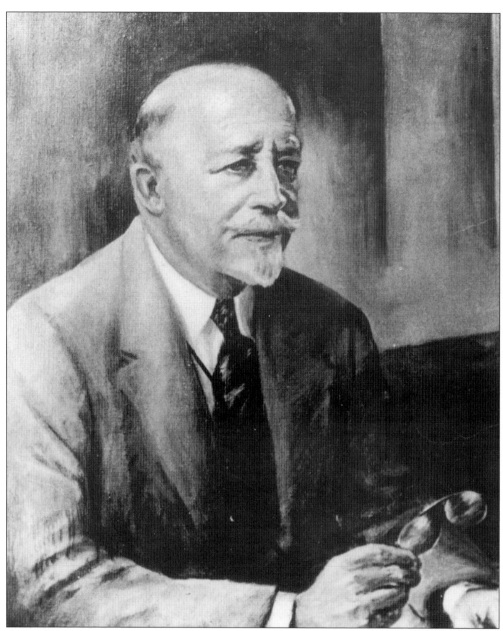

William E. B. DuBois was an editor, writer, teacher, and activist. A graduate of Fisk University, he returned to teach at the school. His philosophy of black advancement and development would seem to contrast that of Booker T. Washington's "Cast your buckets where you are" stance. DuBois called for the "Talented Tenth," a cadre of scholars and professionals who could take the race in any direction it wished to go. The philosophies of both men influenced Nashville and both philosophies had their relevance. DuBois disdained Washington's "Atlanta Compromise," and went on to be part of the Harlem Renaissance and the Niagra Movement that led to the founding of the NAACP. While at Fisk, DuBois kept the waters troubled and pushed for a black president of the school.

James Carrol Napier, Esq., was one of Nashville's most impressive men. A politician, attorney, government employee, and elected official, he was conservative and loyal to the Republican Party. Nonetheless, he often took a bold stand in the interest of black issues. Born of free parents in antebellum Nashville, he was the grandson of a white man associated with Nashville's profitable ironworks.

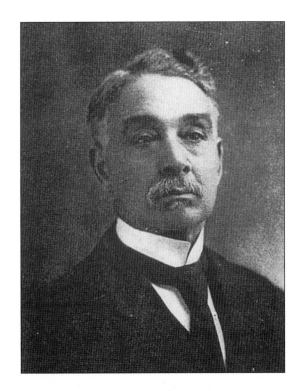

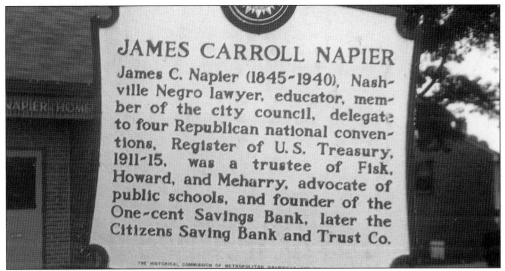

JAMES CARROLL NAPIER

James C. Napier (1845-1940), Nashville Negro lawyer, educator, member of the city council, delegate to four Republican national conventions, Register of U. S. Treasury, 1911-15, was a trustee of Fisk, Howard, and Meharry, advocate of public schools, and founder of the One-cent Savings Bank, later the Citizens Saving Bank and Trust Co.

THE HISTORICAL COMMISSION OF METROPOLITAN NASHVILLE

This historic marker on Lafayette Street cites the life of a remarkable man who made a tremendous impact on the growth and development of the city of Nashville. A man loyal to his political party, he nevertheless did not compromise his principles and was a strong advocate for his people. His strategies had much to do with the decline in white missionary teachers for black children and the assigning of black teachers to instruct African-American children.

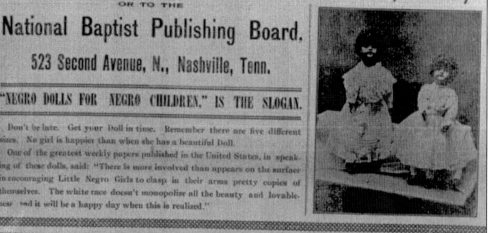

HAVE YOU SENT IN YOUR ORDER

FOR YOUR

NEGRO DOLL

YOU SHOULD SEND IT IN AT ONCE TO THE

NEGRO DOLL COMPANY, OF NASHVILLE, TENN.,

OR TO THE

National Baptist Publishing Board.

523 Second Avenue, N., Nashville, Tenn.

"NEGRO DOLLS FOR NEGRO CHILDREN." IS THE SLOGAN.

Don't be late. Get your Doll in time. Remember there are five different sizes. No girl is happier than when she has a beautiful Doll.

One of the greatest weekly papers published in the United States, in speaking of these dolls, said: "There is more involved than appears on the surface in encouraging Little Negro Girls to clasp in their arms pretty copies of themselves. The white race doesn't monopolize all the beauty and lovableness and it will be a happy day when this is realized."

if the pastor and his family were surprised made no sign. I did not wait nor hesitate, told my story; it had become necessary for me confess my Saviour.

rejoice in the Lord," said the young pastor. u shalt rejoice over every good thing that the I hath given thee. Verily, this is a good thing. e is a duty of delight. There is something to ht in; we forget that."

at was the beginning of my new life. I never red for an instant; I went to meeting for the time in twelve years. I told my story, and good people took me on faith and experi; they stood by me and upheld me. I had exted Satan; my past pleasures had no further nation for me. I had proved my grandmothwords. I am still finding them true. I tell lory to others that they may be wise in seaand if they have not a heritage of early intion, they have the Bible; it is theirs. Let seek for the highway, praying for guidance, they will be led and be able to say and sing shout, Blessed be the God, who giveth us the ry through our Lord Jesus Christ.—*Mrs. e A. Preston in The Christian Intelligencer.*

THE PILGRIMAGE.

e Israelites were not the only wanderers in desert during those forty years. The malove there, and so were the Midianites; but ere aimless wanderers, preferring the and seeking no other land. Israel was on ge, seeking a better country. Life is not a age to every man. We all pass over the road, but some pass while others only

The son of the desert loves his dreary land. The wild, free life of the desert pleases him. He even likes the struggle in which he is almost compelled to engage, and he thinks that to live by plunder is honorable. The pilgrim comes from cultivated lands and from great cities, and he seeks other and perhaps better lands beyond the desert. His dress, his manner, even the very burdens he carries mark him for a stranger. Not that he is never attracted by desert life. There is something of the savage in every man, and so the pilgrim may leave the rough life of the wilderness with a sigh. But he belongs to a better country and a better life. His home and his treasures are not in the wilderness.

Here we have no continuing city, but we seek a country. We are therefore moving onward, with our faces toward the land we seek. The son of the desert may find some well, shaded by date palms; and, pleased with his little paradise, he may choose to abide there forever; or, lured by the wilderness, he may wander on, but wander with no goal beyond his native desert. It is the purpose that makes the life. Every journey is to be judged by its ending, and every pilgrim is to be judged by his pilgrimage.

But no man is so much a child of heaven that he is not also a son of earth. He may be a pilgrim between two eternities, and the world may be a wilderness to him; but he must sometimes feel that he knows but little of the eternities, and that he loves the wilderness. Besides, the journey is too great for him. Somewhere he must taste the grapes of Eschol and hear the news of the good land, or his heart will fail. He cannot always endure the heat and the toil. Somewhere

He cannot always endure thirst; here and th he must find a fountain. He will grow weary last of seeing clear lakes and green fields in the mirage. Somewhere, before he faces supreme trial, he must climb to the top of s Pisgah and see, though it be ever so dimly, land that lies beyond the Jordan.—*Christian recate.*

NUGGETS OF GOLD.

We attract hearts by the qualities we displ we retain them by the qualities we possess Soward.

* * *

Seek no proud riches, but such as thou may get justly, use soberly, distribute cheerfully a leave contentedly.—*Lord Bacon.*

* * *

It is not the fact that a man has riches whi keeps him from the kingdom of heaven, but t fact that riches have him.—*J. Caird.*

The fact that the grace that is given in time need is measured by that need is what fills a tru ing soul with unspeakable joy.—*Exchange.*

* * *

To make a mistake is not half so serious a m ter as not to know that you made it.—*Selected.*

* * *

The true test of character is where what is borne or done must remain unknown, where t struggle must be begun and ended, and the fidelit be maintained, in the solitary heart.—*Ephrai*

The National Baptist Publishing Board, founded by Richard H. Boyd, has been an effective vehicle in educating and influencing America's black youth. The women's auxiliary, in work with the "Save the Boys Movement" and the presentation of black dolls to black girls, helped to further self pride. The Negro Doll Company fostered, "Negro Dolls for Negro Children."

A branch of the National Association for the Advancement of Colored People finally came to Nashville in 1919, and some complained that the branch was too conservative. Although it lacked an on-going program, it often rose to the occasion in crisis. It generally supported black innovators in their efforts. In the 1920s, it was part of protests that occurred when two black men were victims of false rape charges; one of the two was lynched in 1924, being taken from the county hospital. J.W. Frierson, a successful realtor, bequeathed property on Jefferson Street to ensure that the branch would always have an office for its work.

A group of people gather for a race relations meeting in the 1940s. Mrs. Cook, an English teacher at Washington Junior High School, was in attendance.

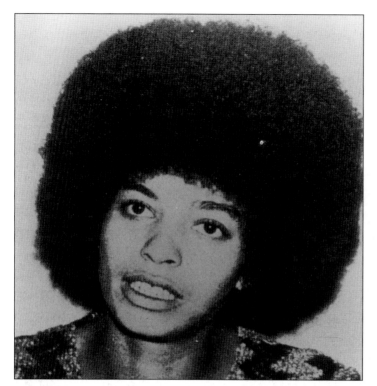

Angela Davis, called a radical in the 1960s, is a Fisk graduate that returned to Nashville to join John Lewis, an American Baptist Theological Seminary student, and James Lawson Jr. in the sit-ins to integrate public eating facilities.

Nikki Giovanni was also a Fisk graduate, as well as a poet. She participated in the 1960s demonstrations and used the power of her pen to facilitate protest.

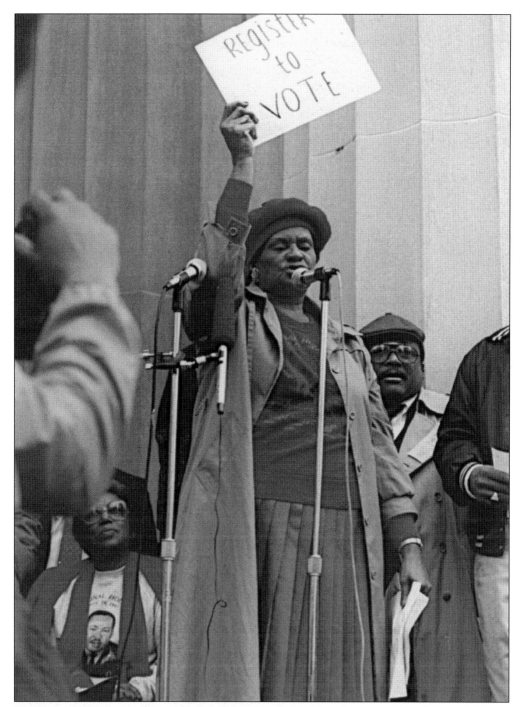

It was the NAACP with Avon Williams and Richard Dinkins that waged the fight to increase the integration of the schools when that process was lagging in the 1970s. One of the branch's most effective presidents was Curlee McGruder. McGruder was committed to youth work and "getting out the vote." Jefferson Street Baptist Church honors her each year by naming a Black History Month seminar for her.

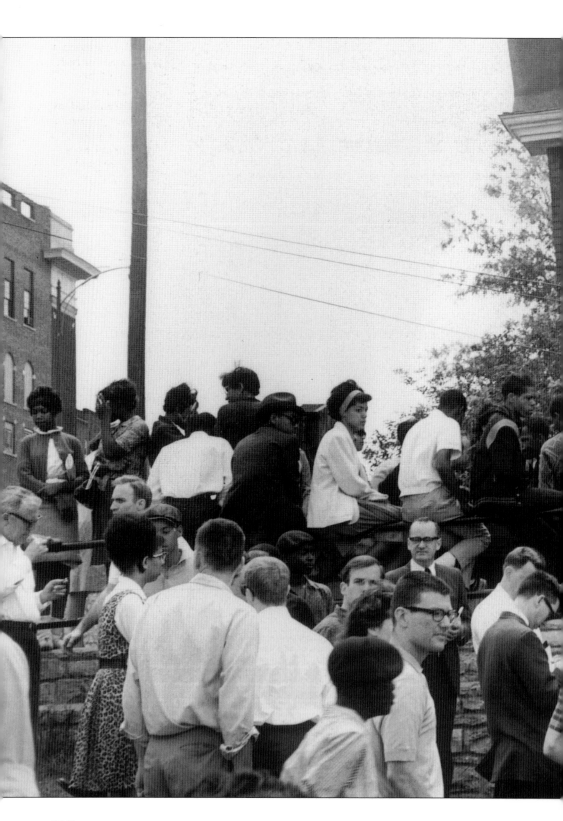

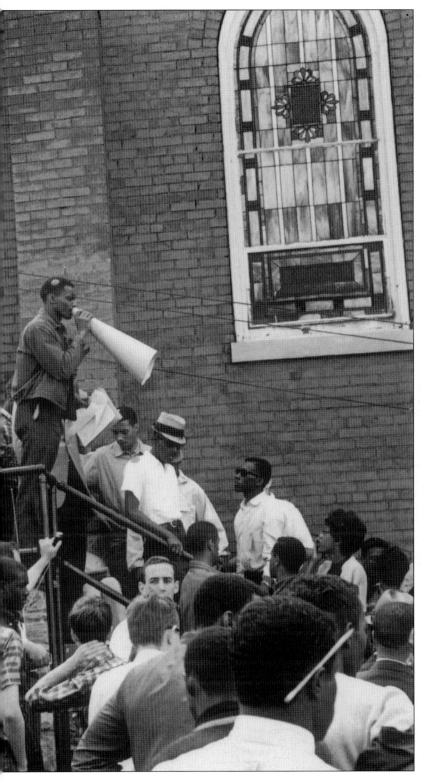

Demonstrators
gather outside
First Baptist
Church,
Capitol Hill, as
they prepare a
march on
downtown's
segregated
facilities.

119

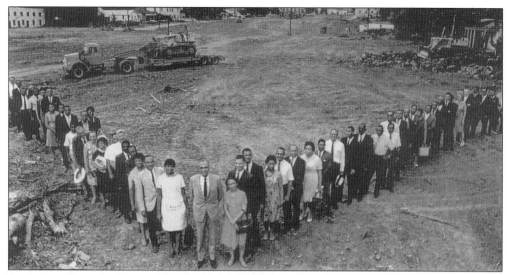

As the interstate highway system broke ground in its work in the 1960s, citizens came out and stood in the way of the work, halting its progress for a time. The highway crisscrossed Nashville communities and reduced many of them to blighted areas.

Church Street was the main shopping thoroughfare in downtown Nashville prior to 1970. Huge signs urging payment of poll tax were often strung across the street prior to the repeal of the Poll Tax Law. Blacks spent thousands of dollars along this street and others, but had to go to the black business district for water, food, and rest room facilities.

Rev. Kelly Miller Smith, pastor of First Baptist Church, Capitol Hill, was named local coordinator to the Southern Christian Leadership Conference unit in Nashville and First Baptist Church became the headquarters.

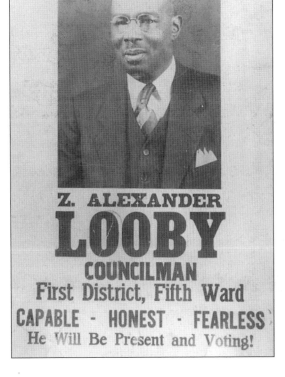

Noted civil rights attorney Z. Alexander Looby moved on to another plateau and ran successfully for a councilman's seat in the First District, Fifth Ward. His former law partner, Avon Williams, won a seat in the Tennessee State Senate.

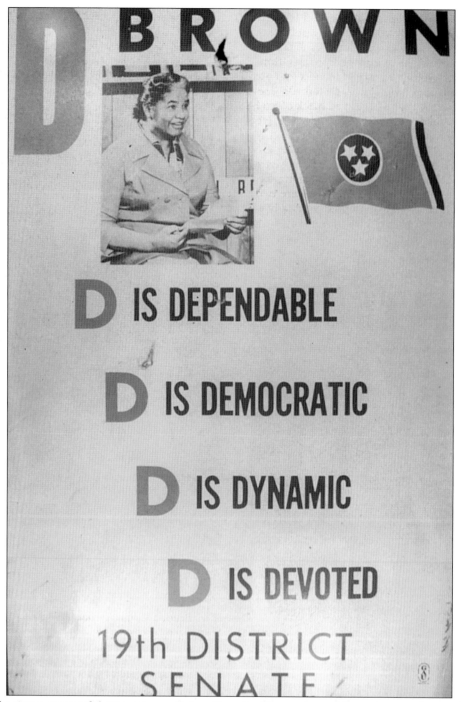

Following a successful career in medicine, Dorothy Brown turned her talents and energies to politics. She was the first black woman to serve in the Tennessee State Legislature representing the Fifth District.

Black Nashville has experienced curves in its political life. Following black oppression at the turn of the 20th century, poll tax, and manipulations in district representation, African Americans experienced a long dry season in getting blacks elected. After several decades without an elected black official, in 1951 change came; still, getting an at-large black candidate did not become a reality until 1999, when Dr. Carolyn Tucker and Howard Gentry Jr. were elected as Metro Council persons. Meanwhile, Saletta Holloway and Brenda Gilmore were two candidates that won in predominantly white districts and over white incumbents in 1999.

Brenda Gilmore, newly elected Metro Council person, won her seat from a white female incumbent. Articulate and effective, Gilmore's election, along with the election of Saletta Holloway, who also won a seat on the council from a predominantly white district, seems to reflect the growing trend among the electorate in the city to chose the best or better candidate without regard to ethnicity.

Mary Frances Berry is another Nashville success story. Rising from limited resources she graduated from Fisk University and went on to law school. She is a distinguished jurist, historian, and professor, and has served as chairperson of the U.S. Commission on Civil Rights. In the 1980s she battled Clarence Pendleton and the Reagan administration's efforts to roll back civil rights progress.

Avon Williams was born in Knoxville, TN, and received two law degrees from Boston University. He did a stint with his older cousin, Thurgood Marshall, and the legal defense section of the NAACP. In 1952, Williams moved to Nashville to join the practice of distinguished civil rights lawyer Z. Alexander Looby. The duo fought innumerable battles to vindicate the rights of black Americans. Their cases ranged from lunch counters to classrooms. In 1955 Williams, Z. Alexander Looby, and Thurgood Marshall of the NAACP, filed suit on behalf of Robert Kelley, who was denied admission to East High School. The suit was won in 1956. In 1969, Williams began his own practice and in 1966 became the first black ever elected to the Tennessee Senate. In 1986 he was honored when the downtown campus of Tennessee State University was named for him.

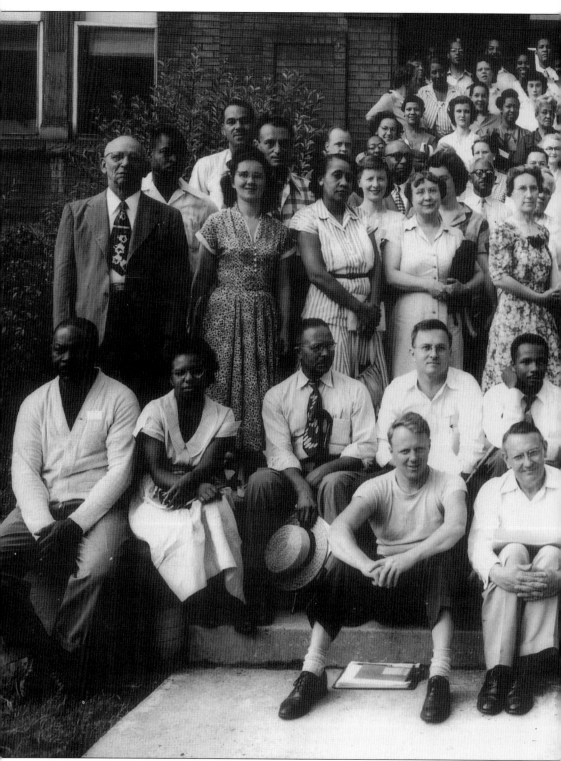

The Race Relations Institute at Fisk University pulled together some of America's sharpest

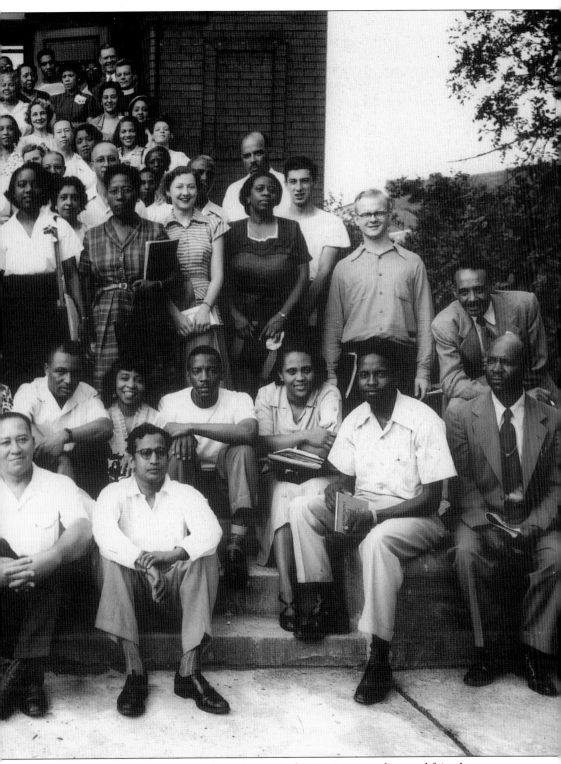

minds to interact with grassroots citizens interested in justice, equality, and fair play.

BIBLIOGRAPHY

Bragg, Emma, Ph.D. *Scrapbook: Some Family Reminiscences...* Nashville: Metro Historical Commission, 1985.

Cox, Chars Marvin. *The Free Negro in Antebellum Nashville*, 1830–1860. (MS Thesis). Nashville: Tennessee State University, 1979 .

Doyle, Don H. *Nashville in the New South*, 1880–1830. Knoxville: University of Tennessee Press, 1985.

Nashville Since the 1920s. Knoxville: University of Tennessee Press, 1985.

Goodstein, Anita S. *Nashville, 1700–1860: From Frontier to City.* Gainesville: University of Florida Press, 1989.

Hale Hospital Review and Social Service Quarterly, volume 1, number 1, December 1926.

Jones, Yollette Trigg. *The Black Community: Politics and Race Relations In the "IRIS CITY," Nashville, Tennessee, 1878–1954.* (Ph.D. Dissertation). Purhain, NC: Duke University 1985.

Kapolowitz, Craig C. "A Breath of Fresh Air: Segregation, Parks, and Progressivism in Nashville, Tennessee, 1900–1920." *Tennessee Historical Quarterly*, Volume LVII, Number 2, Fall 1998. pp.132–149.

Lamon, Lester C. *Blacks in Tennessee, 1791–1970.* Published in cooperation with the Tennessee Historical Commission. Knoxville: University of Tennessee Press, 1981.

Black Tennesseans, 1900–1930. Knoxville: University of Tennessee Press, 1977.

Lovett, Bobby. *A Black Man's Dream. The First One Hundred Years. The Story of R.H. Boyd and the National Baptist Publishing Board.* Mega Corporation, 1993.

Seay-Hubbard United Methodist Church. *A Tradition of Hope.* Nashville: The Church.

Morton-Young, Tommie. *Afro American Genealogy Sourcebook.* New York: Garland Publishing, 1987.

Official Guide. Tennessee Centennial and Exposition.1897.

Tennessee Historical Commission. *Journey to our Past: A Guide to African American Markers in Tennessee.* (Nashville): The Commission, 1999.

Walden University. Nashville, Tennessee, *Catalogue of 1903, 1904.* Nashville: Marshall and Bruce Printers, 1904.

Wooldridge, John. *History of Nashville Tennessee.* Publishing of the Methodist Episcopal Church South. Nashville: 1890